Rachel Rose: Wil-o-Wisp
Edited by Erica F. Battle

The Future Fields Commission
in Time-Based Media

Fondazione Sandretto Re Rebaudengo, Turin

Published in association
with Yale University Press
New Haven and London

Philadelphia Museum of Art

Published on the occasion
of the exhibition *Rachel Rose:
Wil-o-Wisp / The Future
Fields Commission*

Philadelphia Museum of Art
May 1–September 16, 2018

Fondazione Sandretto
Re Rebaudengo
November 2, 2018–
February 3, 2019

Produced by the Publishing
Department, Philadelphia
Museum of Art
Katie Reilly, The William T.
Ranney Director of Publishing
2525 Pennsylvania Avenue
Philadelphia, PA 19130-2440
philamuseum.org

Published in association with
Yale University Press
302 Temple Street
P.O. Box 209040
New Haven, CT 06520-9040
yalebooks.com/art

Inside cover image: Pieter van
der Heyden, after Pieter Bruegel
the Elder, *Summer (Aestas)*,
from the series *The Seasons*, 1570
(see p. 31, ref. image 11)

The exhibition at the Philadelphia
Museum of Art was made
possible by The Pew Charitable
Trusts, Lyn M. Ross, Emily and
Mike Cavanagh, Susan and
James Meyer, and Mitchell L.
and Hilarie L. Morgan. Funding
for both the exhibition and the
accompanying publication was
provided through the Museum's
endowment, via The Daniel W.
Dietrich II Fund for Contemporary
Art. Additional generous support
for the publication was provided by
the Fondazione Re Rebaudengo,
Gavin Brown's enterprise, and
Pilar Corrias Gallery.

Rachel Rose
Wil-o-Wisp

Fondazione Sandretto Re Rebaudengo, Turin

The Future Fields Commission
in Time-Based Media

Philadelphia Museum of Art

Foreword

Timothy Rub
The George D. Widener
Director and Chief
Executive Officer
Philadelphia Museum of Art

Patrizia Sandretto
Re Rebaudengo
President
Fondazione Sandretto
Re Rebaudengo

Wil-o-Wisp, a new work by the American artist Rachel Rose, is the inaugural project of the Future Fields Commission in Time-Based Media, a program recently established by the Fondazione Sandretto Re Rebaudengo and the Philadelphia Museum of Art. Intended to foster experimentation in the languages of film, video, performance, and sound, this collaboration arose from a shared institutional goal to support emerging talent and innovative artistic practices.

It was with this mission in mind that the Fondazione Sandretto Re Rebaudengo was founded in Turin in 1995 as a space for contemporary art research, production, exhibition, and collection, with a focus on showcasing young artists from all over the world. An international component is central to the work of the Fondazione, and this alliance with the Philadelphia Museum of Art is precisely aligned with the synergistic, exchange-based approach that sets it apart.

Of the great encyclopedic art museums in the United States, the Philadelphia Museum of Art has long been known for its embrace of contemporary art and its commitment to working closely with artists. The expansion of this dedication to the burgeoning field of time-based media was a logical step for the Museum to take, and in the Fondazione Sandretto Re Rebaudengo it found an ideal partner.

The Future Fields Commission in Time-Based Media was established with the conviction that an institutional commitment can play a pivotal role in fostering the production and dissemination of work that is not only ambitious, original, and daring, but also perhaps beyond the means of a young artist to undertake at a critical point in his or her career. By providing financial and institutional support as well as an expansive time frame for the realization of a project, this commission gives artists the opportunity

to explore uncharted territory, test new ideas, and devise new production methods.

This was a call that Rachel Rose responded to with gusto, imagining a fascinating new direction for her work that immediately won us over. *Wil-o-Wisp* takes us on a seductive journey back in time, telling a story rich in dramatic contradictions, between progress and decadence, intuition and superstition, and materialism and spirit. Rose invites us to reflect on the dreamlike nature of the images she has created, evoking magical forces that cure and consume, unite and divide, and seduce and frighten, as much today as they must have in the past.

While Rose's previous work drew upon existing images, which she deftly combined to create new and different meanings, *Wil-o-Wisp* represents a significant step forward for the artist, in which she engages with many different aspects of storytelling—writing, staging, acting, framing and with what she and curator Erica Battle call, in their illuminating conversation included in this book, the depth of the image. This density of experience is also echoed in the space where the video is exhibited, conceptualized by Rose in exquisite detail to emphasize how the experience of seeing and encountering images does not end with the screen, but rather is one with the space we inhabit— a space that might be described as slightly bewitched.

This project is the first fruit of a partnership between the Fondazione and the Museum that is being built upon a longstanding relationship. Since 2008, Patrizia Sandretto Re Rebaudengo has served as a member of the Museum's Contemporary Art Committee, a forum that stimulates debate and the sharing of knowledge, from which the original idea for this initiative was developed in conversations between us and Carlos Basualdo, the Museum's Keith L. and

Katherine Sachs Senior Curator of Contemporary Art. His vision for the program has been crucial to its successful launch. The first work produced under its auspices will enter both of our collections as a co-acquisition, and will serve as a lasting testament to the importance of institutional policies and strategies based on international collaboration.

We would like to thank the project's organizer, Erica F. Battle, The John Alchin and Hal Marryatt Associate Curator of Contemporary Art, who worked with Rose during every stage of the production process and was an astute interpreter and invaluable mediator of her thoughts. She is also responsible for assembling this book, which masterfully guides us through the creation of *Wil-o-Wisp*, offering an analysis that is further enriched and deepened by the brilliant contribution of Erika Balsom, to whom we are very grateful. We would also like to thank Irene Calderoni, curator of the Fondazione Sandretto Re Rebaudengo, who organized the presentation of the work in Turin and is part of the curatorial team responsible for overseeing the Future Fields Commission in Time-Based Media.

Commissioning a new work is always an adventure, an experience fraught with anticipation and surprise. Accompanying the artist on this journey, from the initial conception to the finished work, is likewise always an honor and a privilege. For these reasons, our greatest thanks go to Rachel Rose, for the dedication, generosity, and talent she poured into this project. Though still in the early stages of her career, Ms. Rose has already demonstrated an extraordinary vision that places her among the most relevant voices of her generation, and the Future Fields Commission is intended both as recognition of the work she has already achieved and as a token of a bright and promising future.

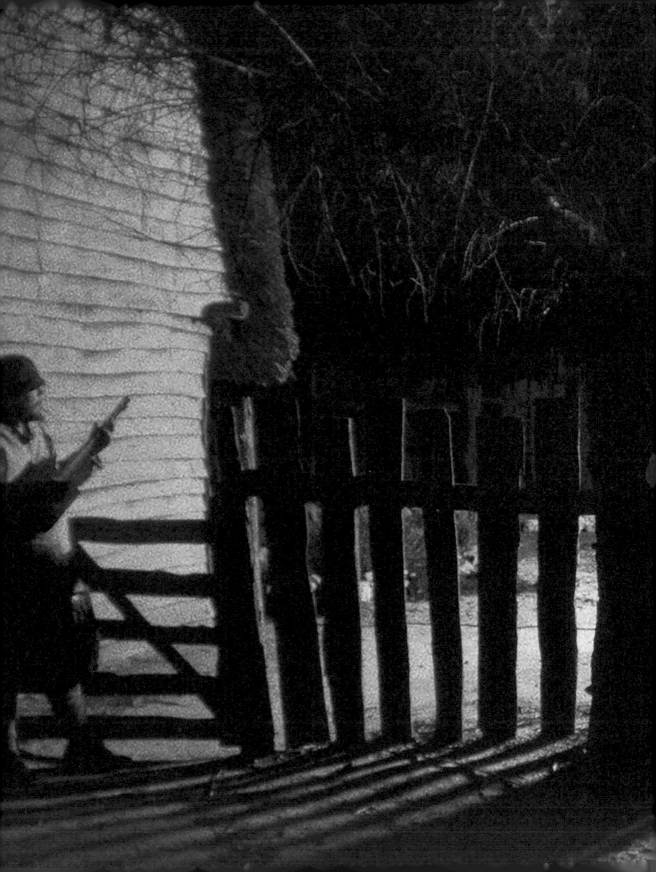

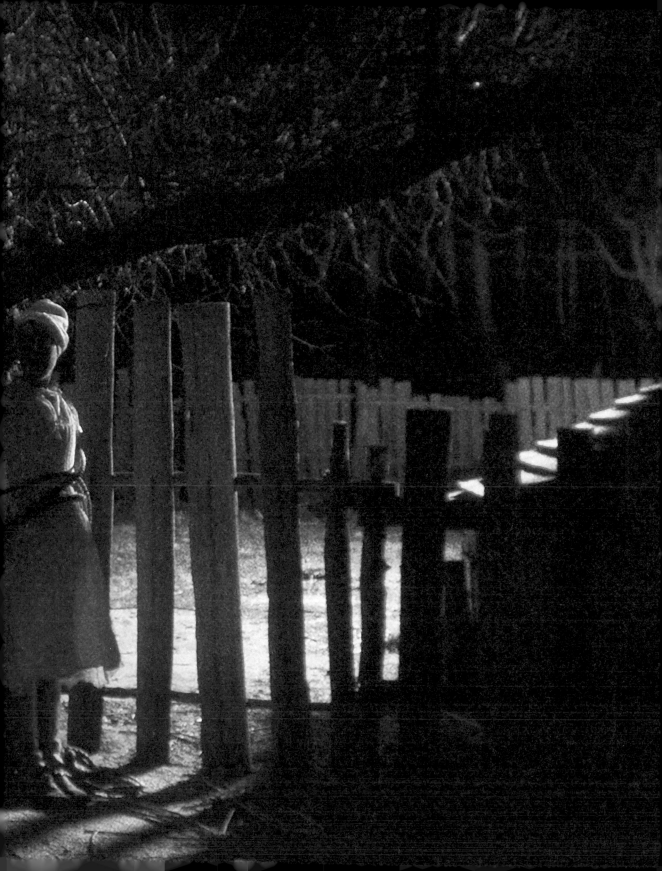

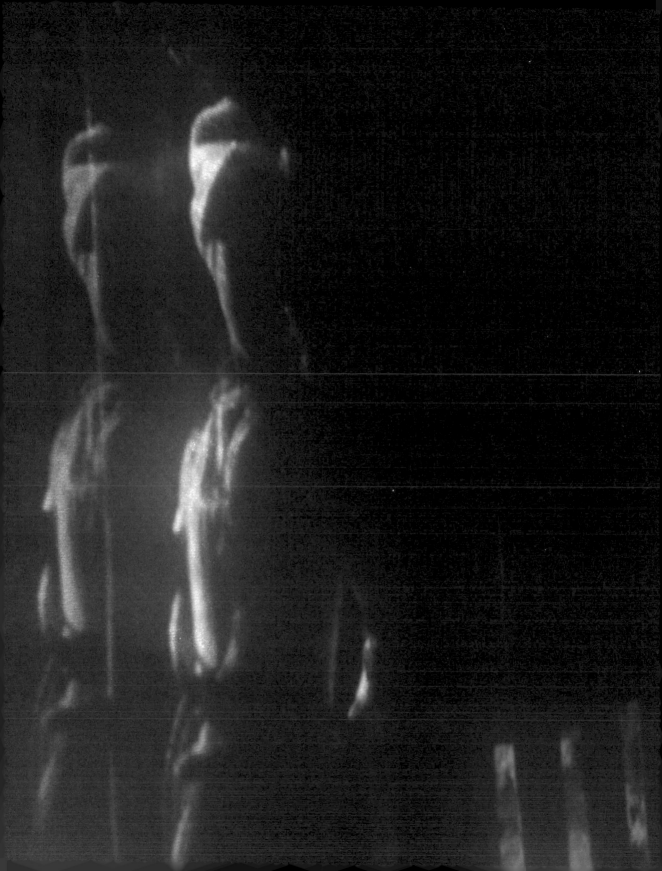

Enclosures and Escapes

Erika Balsom

A helicopter falls from the sky, but perhaps it is happening on a film set, part of a planned spectacle. Catastrophe or entertainment? These days, it can be hard to tell. From this first image of Rachel Rose's first video, *Sitting Feeding Sleeping* (2013), things are going wrong and certainty is elusive. Against the oozing blue of jellyfish, jarring flashes of red issue a warning of "media offline" in six languages (fig. 1), a global alert of machine failure. Images bend and crumple, flicker and layer, as they can only when made of pixels, with evocations of cryogenic freezing, corporeal regeneration, humanoid robots, and the specter of species extinction emerging from the flux. Strewn through this collage of fragments is a menagerie of animals, one of the rarest commodities in Philip K. Dick's dystopian imagining of life after environmental catastrophe, *Do Androids Dream of Electric Sheep?*, so rare that in his fictional world their presence is simulated by robots nearly indistinguishable from the real thing.[1] In Rose's vision, we are almost there: nature and technology are inseparable, the border between the animate and inanimate is blurred, and a premonition of coming crisis commingles with a sense of wonder. It is nothing less than a portrait of twenty-first-century existence.

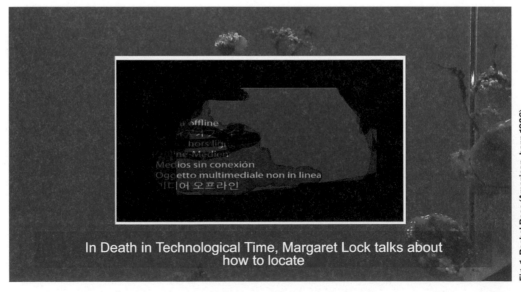

In Death in Technological Time, Margaret Lock talks about how to locate

Fig. 1. Rachel Rose (American, born 1986). *Sitting Feeding Sleeping*, 2013

Rose's concern with modernity's ambivalent promise of progress and the looming threat of anthropogenic climate emergency continues in subsequent works, particularly *A Minute Ago* (2014), which begins with a video, sourced from the internet, of a sudden and violent hailstorm on a beach in Siberia (see fig. 16). Rose deploys this unsettling footage within a constellation of other sounds and

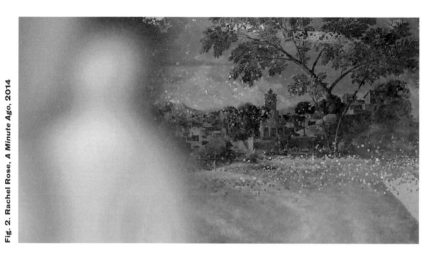

images, including Pink Floyd's concert at the buried city of Pompeii, Philip Johnson's Glass House, and Nicolas Poussin's *The Burial of Phocion* (c. 1648–49), a scene of unjust punishment and death staged in a classical landscape, which Johnson purchased in 1945. As these images shatter and superimpose (fig. 2), blending together as much as they break into shards, the optimism and transparency emblematized by the modernism of the Glass House is contaminated by forces of degradation, disaster, and digitality. Stability and balance vanish, as the world is engulfed in ceaseless movement that is possibly destructive and doubtlessly transformative.

Like *Sitting Feeding Sleeping*, *A Minute Ago* is marked by a distinct sensation of contemporaneity. In the malleability of their composited, maximalist images as much as in their simultaneous solicitation of pleasure and dread, these works capture the feelings of anxious overstimulation and fading materiality that mark our intuition of the now.

Rose distills this ambient mood, forever present in the low hum of the everyday, until it reaches fatal, palpable potency, doing so without ever trading beauty for untrammeled negativity. Within this affective intensity, one senses a delicate uncertainty concerning the continuing viability of the modern project and its belief in a logic of progress driven by the twin engines of industry and technology.

After such a deep immersion in the impasses of the present, and at a time when most imaginable futures are dystopian, where does an artist turn to avoid relinquishing all hope? In *Wil-o-Wisp* (2018), her sixth video, Rose makes a decisive move, unfolding a historical fiction of magical healing and persecution against the backdrop of the enclosure of common lands in England at the turn of the seventeenth century. In a tale set amid a process that Karl Marx deemed instrumental in the transition from feudalism to capitalism and that paved the way for the Industrial Revolution[2]—a tale that must be understood in dialogue with the artist's established interest in the experiential textures of late modernity—Rose delves into the looping temporalities of the past, finding there both the enduring possibility of enchantment and the roots of our current condition.

The will-o'-the-wisp is the *ignis fatuus*, a term meaning "foolish fire," designating a phosphor-escent light glimpsed over a marsh or bog. According to folk legend, such apparitions were the work of mischievous or even condemned fairies who deliberately lured travelers down the wrong path, giving rise to figurative uses of *will-o'-the-wisp* to refer to anything that purposely misleads or,

Fig. 3. Rachel Rose, *Palisades in Palisades*, 2014

alternatively, constitutes an unattainable goal.[3] In fact, the phenomenon is the product of the spontaneous combustion of gases emitted from decaying organic matter. If the *ignis fatuus* is not a question of deception or folly, it is a question of death; either way, this vision of light is dark in meaning.

Rose's *Wil-o-Wisp* finds its central narrative tension in the struggle between occultism and rationality embedded in its title, as it follows the character of Elspeth Blake, a mystic and healer, through two episodes across three decades, both located in Somerset. In the first, set in 1570, Elspeth is married with two children, living on public land. Under a glowing scarlet moon, her elder daughter sneaks out for a walk at night, dropping her bonnet too close to the fire and accidentally burning down the family's cottage. When the ashen bodies are recovered, Elspeth's is missing. An unclaimed cow appears on the same day, and the townspeople speculate that it is she, metamorphosed. Thirty years later, Elspeth enters the nearby village of Stogursey and becomes known for her healing powers, only to fall afoul of the local prefect at a time when the

enclosure of formerly common lands was inspiring a growing concern with private property and capital accumulation. The facts of Elspeth's story are relayed without dialogue, in a series of impressionistic fragments, with particulars communicated in an economical and matter-of-fact way, first in a spoken female voiceover accompanied by whimsical music, and later in a solemn sung passage. Neither gives any indication of support for the character or attempts to provide an explanation of her mysterious gifts, but instead plainly recounts her travails.

It is in the work of the image that *Wil-o-Wisp* makes evident its deep investment in enchantment, and that Rose shows herself sympathetic to the powers Elspeth derives from what the voiceover calls the "divine balance that connects all living things." Although *Wil-o-Wisp* ventures into narrative terrain previously unexplored by the artist, Rose's signature use of postproduction software tools remains in force, albeit in a manner somewhat tempered by the need to maintain the consistency of a diegetic universe. Through her digital manipulation of the image, Rose creates the world of the film as a world of wonder, one abiding by rules very unlike those

of our own. If, in 1839, François Arago announced to the French Chamber of Deputies that the camera would join the thermometer and barometer as scientific instruments of observation, yoking the new medium of photography to modern disenchantment and the registration of physical reality,[4] Rose positions herself today within an altogether different lineage, courting the possibilities of a marvelous, palpably artificial, antirealist cinema first employed in the films of Georges Méliès.

Wil-o-Wisp embraces plasticity, nonreferentiality, and compositing, proclaiming that its pictures are made, not taken. While Rose employs the lens-based capture of actors and locations, this is but a preliminary stage of image production. Processed through her arsenal of effects, the status of the work's historical mise-en-scène is rendered not unlike that of the painting of George Washington examining maps that appears in her

Palisades in Palisades (2014; fig. 3):[5] these are crafted, nonindexical representations. Patterns of solar illumination change suddenly, defying the laws of nature. A shape-shifting moiré pattern intermittently covers the picture plane, at once endowing scenes with a sense of otherworldliness and casting a determinedly anachronistic electronic veil over this period piece (see pp. 54, 58). Select uses of color—moss glowing green on a rooftop, an iridescent blue bird flying through a barn window, purple fog—similarly disrupt the naturalism of recording, while titles laid over images, derived from the anthropomorphic initials of a medieval book of hours (fig. 4; p. 53), chime with Rose's longstanding practice of incorporating historical works of painting into her videos and foreground flatness through superimposition.

Yet nowhere is *Wil-o-Wisp*'s affinity with magical transfiguration clearer than in the sequence that

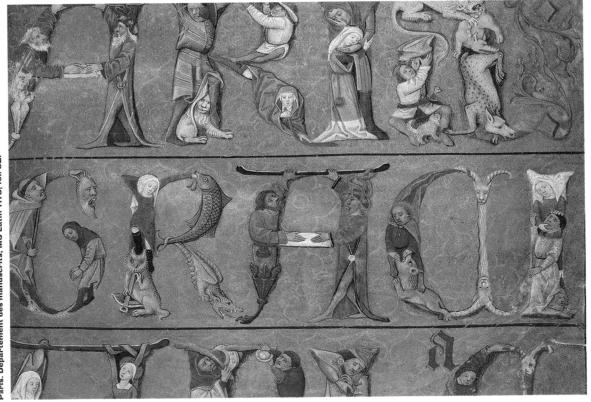

Fig. 4. Detail of Horae ad usum Parisiensem, from *Les Heures de Charles d'Angoulême*, 1475–1500. Bibliothèque nationale de France, Paris. Département des manuscrits, MS Latin 1173, fol. 52r

depicts Elspeth's expulsion from Stogursey. Accused of theft and witchcraft, she is escorted from the village by force. As the sung voiceover lists the charges leveled against her—crops stolen, spells cast—Elspeth stoops in a dark field, positioned before a large screen onto which these episodes are projected. The status of these images is uncertain: they may be visions of the past or the imaginings of gossip. Either way, many are invaded by a quivering sun-like light that moves nervously, casting its glare across the frame (see p. 63). As Elspeth proceeds down the road leaving the village, the officials at her side fade to naught, vanquished through the agency of a dissolve. She is free to leave alone—but an even greater sea change is in store.

A substitution splice renders Elspeth's departure from Stogursey merely a projection on the screen in the field, an image exhibited within a parallel reality in which a second Elspeth stoops before her cinematic alter ego to glean grains, as she had prior to her exile (see p. 66). Time's arrow has broken, splintering into coexisting yet incompossible worlds, denying the existence of a unified present and troubling the easy succession of past to future. As the projection of Elspeth fades, the screen is overtaken by blurred, black-and-white images of a procession of fairies, borrowed from the 1935 film adaptation of *A Midsummer Night's Dream* (see pp. 67, 68). The supernatural aura of the moiré fog envelops the world as up-tempo electronic music swells on the soundtrack. A purple mist blows across fantastical, transhistorical landscapes, created by reviving the specters of classical cinema within a digital phantasmagoria, resulting in a composite image that is itself a denial of distinctions between past and present. A hint of this gaseous, ethereal domain of

parallel temporalities and parallel worlds has been glimpsed twice before, just fleetingly, when Elspeth crawls out of her burning house, and again amid the projections of her apparent misdeeds. Now, however, it returns with lasting force to command control. Suddenly, with a swift cut, all is restored: *Wil-o-Wisp* loops back to its opening image, and Elspeth lives with her family once more. The same electric blue bird that had flown through the barn window as she healed a sick man in Stogursey perches atop the roof of her still-intact cottage (see p. 68).

In *Sitting Feeding Sleeping*, Rose's voiceover describes the moving image's powers of temporal reversibility with reference to Thomas Edison's *Electrocuting an Elephant* (1903): "Replay it on YouTube and the animal becomes alive and re-dead, as many times as you watch it." The loop's capacity for reanimation feeds a perhaps cruel curiosity in Rose's YouTube spectators, but in *Wil-o-Wisp* it is the vehicle of Elspeth's liberation. Rather than face expulsion from her village and a life lived amid an impoverishment of the commons and the pathologizing of folk tradition, she begins again, traveling back in time just as inexplicably as she traveled forward. The two moments she inhabits are not points on a straight line but accumulated layers; the projection-within-the-projection renders time a

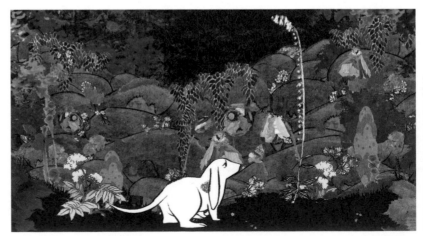

Fig. 5. Rachel Rose, *Lake Valley*, 2016

Fig. 6. Eija-Liisa Ahtila (Finnish, born 1959). *If 6 Was 9*, 1995. Finnish National Gallery, Helsinki. Purchase, 1997-5-23, N-1997-83

matter of thick coexistence instead of mere sequence, with Elspeth able to move between multiple sheets of pastness. The trope of crossing between actuality and virtuality appears already in Rose's previous video, *Lake Valley* (2016), an animated collage positioned on the threshold between dream and waking life in which a hybrid dog-bunny protagonist escapes domestic boredom by entering the lush, seductive forest-world of a painting (fig. 5). *Wil-o-*

Fig. 7. Stan Douglas (Canadian, born 1960). *Subject to a Film: Marnie*, 1989. Courtesy of the artist and David Zwirner

Wisp develops this notion further in its depiction of the screen-portal during key moments of trauma and transformation. When Elspeth is doubled, occupying two moments in time simultaneously, with one Elspeth positioned in "reality" and the other in the screen-within-the-screen, Rose asserts no hierarchy of embodied original and dematerialized copy. Rather, the passage between the two realms is reversible and fluid, with neither able to claim the status of an origin from which the other would be derived.

In this malleability and multiplicity of realities, the linear time of progress—a time that would become endemic to the very modernity taking hold in the period Rose depicts—is denied in favor of a repetitive, reparative return that rejects all teleology. In this avoidance of linearity and finality, Rose follows in the footsteps of artists such as Eija-Liisa Ahtila (fig. 6) and Stan Douglas (fig. 7), who in the 1990s imported exploded forms of cinematic narrative into the

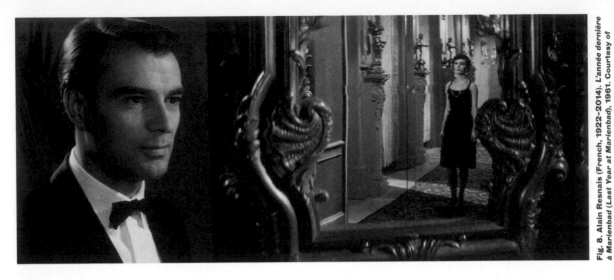

Fig. 8. Alain Resnais (French, 1922–2014). *L'année dernière à Marienbad* (*Last Year at Marienbad*), 1961. Courtesy of StudioCanal

gallery space, pioneering experimental structures that replaced start-to-finish storytelling with circularity, multiple worlds, and nonchronological fabulation. Indebted to films such as Alain Resnais's *Last Year at Marienbad* (fig. 8) and Jacques Rivette's *Céline and Julie Go Boating* (fig. 9), these artists freed filmic narrative from unidirectional trajectories of cause and effect, both as a conceptual challenge to hegemonic notions of temporality and diegetic unity, and as a means of adapting the creation of fictional worlds to the nonlinear viewing protocols of the gallery.

Wil-o-Wisp pushes back against a pervasive contemporary climate of schizophrenic fragmentation to exploit the diachronic movement of narrative as a means of conceptualizing historical change. And yet, in Rose's determined suspension of "The End"—a moment that so rarely ends well for female protagonists in particular—she breaks with narrative's habitual

ideological function of resolving contradiction, instead allowing the tension between nascent privatization and withering communal interconnectedness to stand unreconciled. As the film theorist Laura Mulvey proposed already in 1986, "If narrative, with the help of avant-garde principles, can be conceived around ending that is not closure, and the state of liminality as politically significant, it can question the symbolic, and enable myth and symbols to be constantly revalued."[6] In *Wil-o-Wisp*,

Fig. 9. Jacques Rivette (French, 1928–2016). *Céline et Julie vont en bateau* (*Céline and Julie Go Boating*), 1974. Courtesy of Les Films du Losange, Paris

this revaluation is concerned with commemorating a lost harmony of human and nonhuman life and reasserting the nonlinear temporalities of ritual and nature that would be swiftly usurped by what the philosopher Walter Benjamin termed the "homogeneous empty time" of modernity. Of course, the end of feudalism would improve the quality of life for many, but as Rose suggests, it would entail sacrifices, too.

As much as Rose's turn to narrative and the generic conventions of the heritage drama link *Wil-o-Wisp* to the cinephilic practices of the 1990s that blossomed with the new availability of high-quality video projection, her visual language anchors her within a younger generation, concerned less with cinema than with an image vernacular

Fig. 10. Ryan Trecartin (American, born 1981). *(Tommy Chat Just E-mailed Me)*, 2006. Courtesy of Electronic Arts Intermix, New York

and structure of feeling proper to the internet. In works such as Ryan Trecartin's *(Tommy Chat Just E-mailed Me)* (fig. 10) and Camille Henrot's *Grosse Fatigue* (fig. 11), the unity of the frame gives way to a tessellated surface of overlapping windows, transforming the picture plane into a repository for materials of diverse provenance. Operations of cutting and pasting remake the combinatory aesthetic of artists such as Robert Rauschenberg for the digital age. Illusory depth is relinquished for a proclamation of tactile flatness in synthetic images

that bear the marks of their computer-assisted creation and speak to a condition of information saturation and collapsing categories. Even if *Wil-o-Wisp* retreats from the present at the level of content and makes mitigated use of these formal operations when compared to Rose's earlier work, its visual language remains distinctly anchored in these contemporary concerns.

Whereas Trecartin and Henrot foreground the opaque blockiness of one window as it renders another invisible, Rose's aesthetic of layering is one of translucency, vacillating between opacity and transparency to create relations of coexistence and interpenetration. Permeating layers run throughout Rose's early videos, extending in *Everything and More* (2015) to the use of a fabric screen and vinyl-covered window as a material support that troubles distinctions of interior and exterior in a manner that rhymes with the play between microcosm and macrocosm that occurs within the image (fig. 12). *Wil-o-Wisp* uses translucent layering effects with and against diegetic immersion: on the one hand, they serve a narrative function, visually signaling the presence of otherworldly spirits and imparting an aura of enchantment and plasmatic transformation; on the other hand, they distance the viewer from any impression of reality, underlining the artifice of this reconstructed seventeenth century so as to challenge the simulationism of most historical films and of Plimoth Plantation, the living-history museum in Plymouth, Massachusetts, that Rose used as a shooting location. But perhaps more importantly, these diaphanous layers constitute a visual language germane to the themes of interconnectedness and temporal simultaneity that pervade the work. As in *Everything and More*, this extends to exhibition design as well: at the Philadelphia Museum of Art and the

Fondazione Sandretto Re Rebaudengo in Turin, *Wil-o-Wisp* is exhibited in a room cloaked in white fabric that produces the same moiré effect seen within the image, blurring the boundary between the filmic world and our own (see pp. 56–57). The screen, too, is translucent and layered, with light passing through the front projection surface to meet a second, textured plane that causes a gentle refraction, abstracting the image still further from photorealism and courting a still stronger affinity with the moiré pattern. Crossing to this other side of the screen, the projector's beam shines through like the jittery sun-like light that appears during the recitation of Elspeth's supposed offenses, opening one last passage between actuality and virtuality as the viewer departs the installation.

Fig. 11. Camille Henrot (French, born 1978). *Grosse Fatigue*, 2013. The Museum of Modern Art, New York. Fund for the Twenty-First Century, 1207.201

Have we moderns been seduced by the will-o'-the-wisps of private property and technology, led down a path that ends badly for all, whereby we are condemned to inhabit the state of anxious crisis Rose began to index in *Sitting Feeding Sleeping*? In its enchanted circularity and presentation of a world in which ineffable mysteries persist as part of everyday life, *Wil-o-Wisp* uses distinctly digital means to offer a prelapsarian alternative to narratives of progress that are by now threadbare. Rose finds an escape from the morass of the present in this story of enclosure long past. In a gesture befitting an artist who repurposes so many images not of her own making, she affirms the richness of the commons, attesting to the generative possibilities of nonproprietary ways of living at a time when the logic of privatization is more tenacious than ever. The coexisting sheets of time that accumulate in this work consist not only of Elspeth's life experiences: as the palpable contemporaneity of the moiré effect suggests, bleeding outward from the film to encompass the space of the gallery, we too are implicated. If time is no longer linear, perhaps the past can be redirected toward a different future—a future not dystopian but one in which the "balance that connects all living things" might be rehabilitated, even restored.

1 Philip K. Dick's 1968 novel (published by Doubleday) was made into the 1982 movie *Blade Runner*.

2 Karl Marx, *Capital: A Critique of Political Economy*, vol. 1 (London: Penguin, 1976), 877–96.

3 The figurative definition of will-o'-the-wisp found in the Oxford English Dictionary is "a thing (rarely a person) that deludes or misleads by means of fugitive appearances"; Merriam-Webster (online) defines it as "a delusive or elusive goal."

4 Quoted in Brian Winston, "The Documentary Film as Scientific Inscription," in *Theorizing Documentary*, ed. Michael Renov (New York: Routledge, 1993), 37.

5 The painting is Edward Savage's *The Washington Family*, 1789–96 (National Gallery of Art, Washington, DC).

6 Laura Mulvey, "Changes: Thoughts on Myth, Narrative, and Historical Experience," in *Visual and Other Pleasures* (Bloomington: Indiana University Press, 1989), 175. In 2016, Mulvey and Rachel Rose collaborated on a reprint of her influential essay "Visual Pleasure and Narrative Cinema" on which Rose created collaged, fairy-tale-like images, drawing a connection between these pre-cinematic images and what Mulvey describes. See Mark Lewis, ed., *Rachel Rose—Laura Mulvey: "Visual Pleasure and Narrative Cinema," 1975* (London: Afterall Books, 2016).

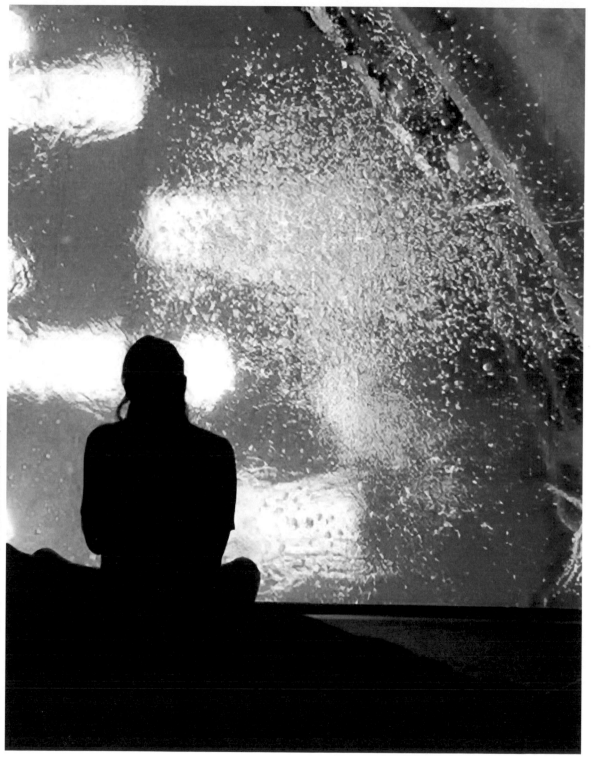

Fig. 12. Rachel Rose, *Everything and More*, 2015. Installation in *The Infinite Mix: Contemporary Sound and Image*, Hayward Gallery at 180 The Strand, London, 2016

Reference Images

1

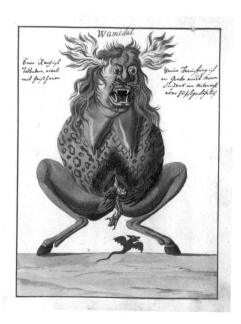

2

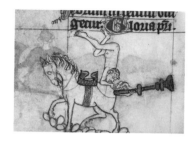

3

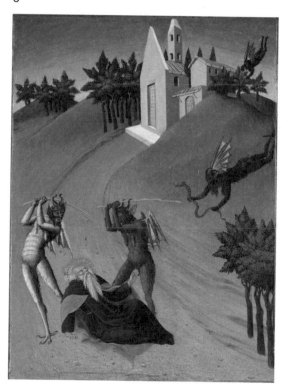

4

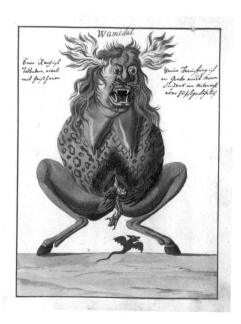

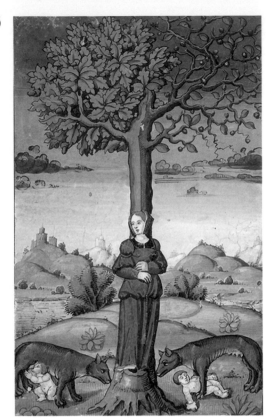

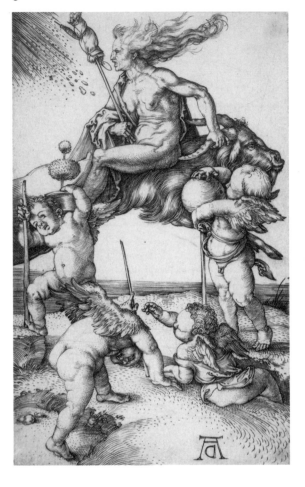

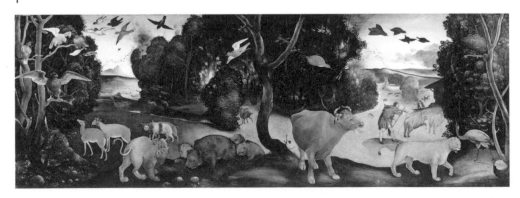

8

9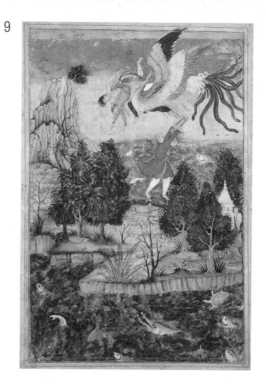

10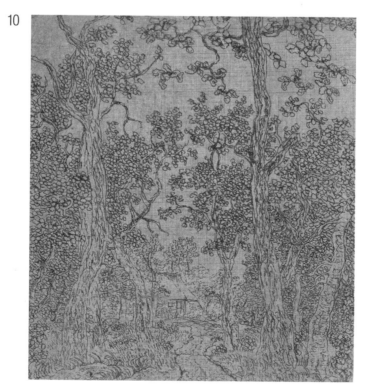

11

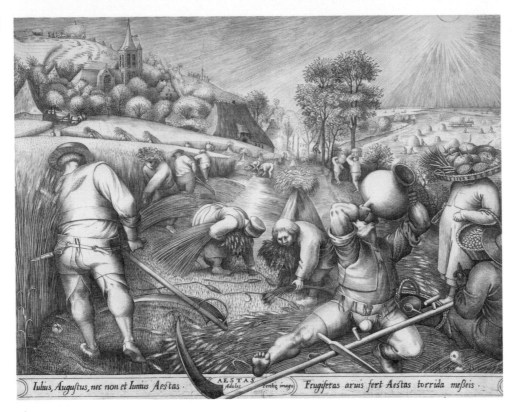

Iulius, Augustus, nec non et Iunius Aestas. AESTAS Frugiferas aruis fert Aestas torrida meßeis.
Adoles cencie imago

12

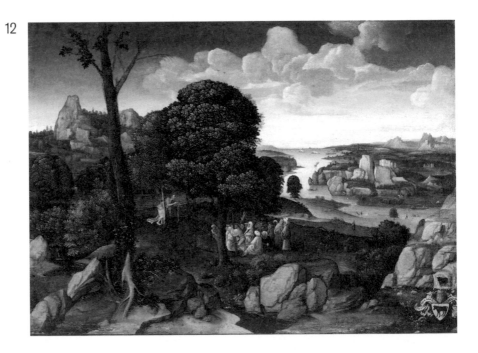

13

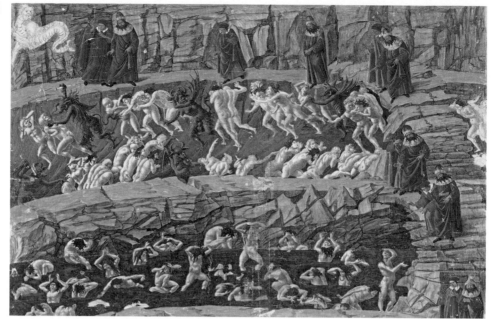

14

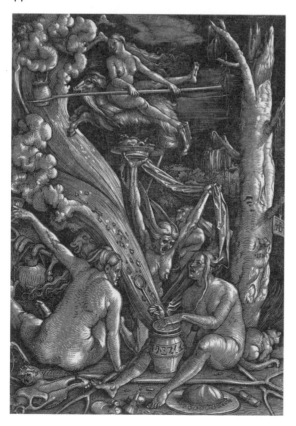

15

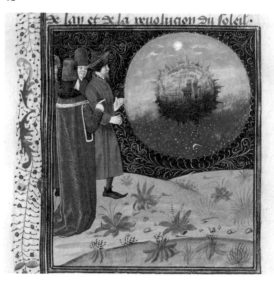

16

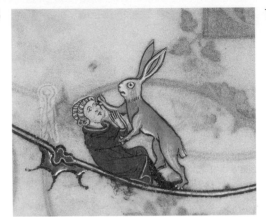

17

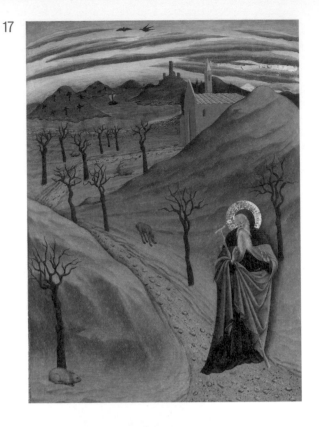

18

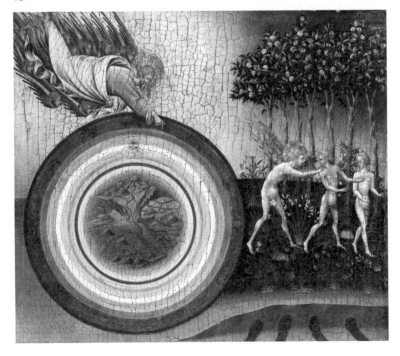

26

19

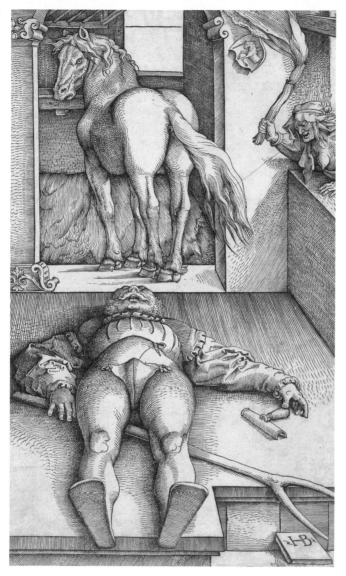

20

21

22

23

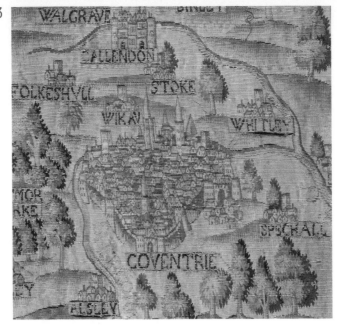

24

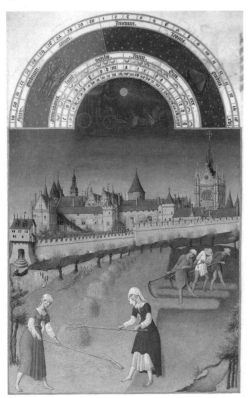

25

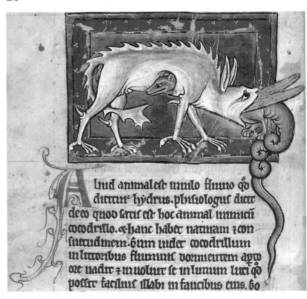

28

26

27

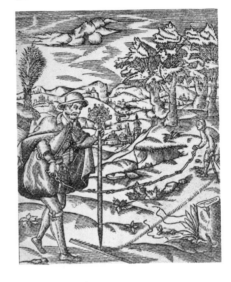

28

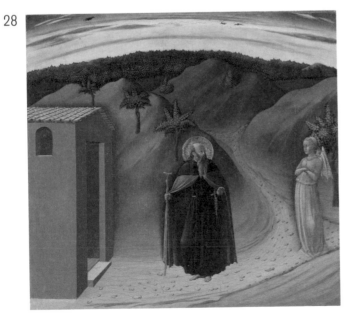

29

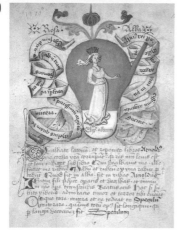

30

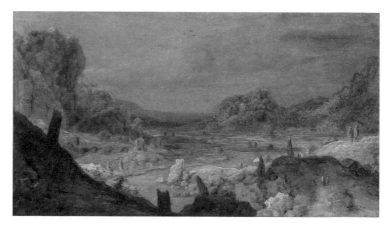

31

32

The images in this section were collected by Rachel Rose and used throughout the development of *Wil-o-Wisp* as visual references.

1 Attributed to Isaac Oliver (English, born France, 1556–1617) or Marcus Gheeraerts the Younger (Flemish, c. 1561/62–1636). *Queen Elizabeth I (The Rainbow Portrait)*, c. 1600–1602. Collection of the Marquess of Salisbury (on display at Hatfield House, Hertfordshire, England)

2 Detail of a page in a Book of Hours, Use of Maastricht (The Maastricht Hours; Liège, Netherlands), 1st quarter of the 14th century. The British Library, London, MS Stowe 17, fol. 153v

3 Sano di Pietro (Italian, 1405–1481). *Saint Anthony Abbot Tormented by Demons*, c. 1435–40. Yale University Art Gallery, New Haven. University Purchase from James Jackson Jarves, 1871

4 A monster (Wamidal) from the *Compendium rarissimum totius Artis Magicae sistematisatae per celeberrimos Artis hujus Magistros* (A rare summary of the entire Magical Art by the most famous Masters of this Art; Germany), c. 1775. Wellcome Library, University of London, MS 1766, fol. 25r

5 Miniature of an allegory of a woman as part of a tree trunk (Northern France), 1525–50. The New York Public Library. Spencer Collection, Ms. 081 [cropped]

6 Albrecht Dürer (German, 1471–1528). *The Witch*, c. 1500. The Metropolitan Museum of Art, New York. Fletcher Fund, 1919.73.75

7 Piero di Cosimo (Italian, 1462–1522). *The Forest Fire*, c. 1505. Ashmolean Museum, University of Oxford. Presented by the Art Fund, 1933

8 Three birds in a flask, and in the border below, the pope, surrounded by cardinals, crowning a suppliant; miniature from the alchemical treatise *Splendor Solis* (Germany), 1582. The British Library, London, Harley 3469, fol. 24r

9 *Young Man Carried off by a Simurgh* (Lahore, India), 1590. Aga Khan Museum, Toronto, AKM140

10 Hercules Segers (Dutch, c. 1590–c. 1638). *Small Wooded Landscape with a Road and a House*, c. 1615–30. Rijksmuseum, Amsterdam; on loan from the City of Amsterdam, RP-P-H-OB-852

11 Pieter van der Heyden (Flemish, c. 1530–1572), after Pieter Bruegel the Elder (Netherlandish, c. 1525–1569). *Summer (Aestas)*, from the series *The Seasons*, 1570. The Metropolitan Museum of Art, New York. Harris Brisbane Dick Fund, 1926.72.23

12 Joachim Patinir (Netherlandish, c. 1485–1524). *Landscape with Saint John the Baptist Preaching*, 1515–18. Philadelphia Museum of Art. Gift of Mrs. Gordon A. Hardwick and Mrs. W. Newbold Ely in memory of Mr. and Mrs. Roland L. Taylor, 1944-9-2

13 Sandro Botticelli (Italian, c. 1445–1510). *Inferno, canto XVIII: Virgil and Dante in the Eighth Circle of Hell*, c. 1490. Kupferstichkabinett, Staatliche Museen zu Berlin

14 Hans Baldung Grien (German, 1484/85–1545). *The Witches*, 1510. The Metropolitan Museum of Art, New York. Gift of Felix M. Warburg and his family, 1941.1.201

15 Astronomers with the earth covered in spires, from a French translation of Bartholomeus Anglicus (Bartholomew the Englishman), *De proprietatibus rerum* (*Livre des propriétés des choses*, trans. Jean Corbechon; Bruges), c. 1470. Bibliothèque nationale de France, Paris. Archives et manuscrits, Français 134, fol. 169r

16 Detail of a page from the *Bréviaire à l'usage de Verdun* (*Bréviaire de Renaud de Bar, Metz, France*), c. 1302–5. Bibliothèque municipale à Verdun, ms. 0107, fol. 096v

17 Master of the Osservanza (Italian, act. c. 1430–50). *Saint Anthony the Abbot in the Wilderness*, c. 1435. The Metropolitan Museum of Art, New York. Robert Lehman Collection, 1975.1.27

18 Giovanni di Paolo (Italian, 1398–1482). *The Creation of the World and the Expulsion from Paradise*, 1445. The Metropolitan Museum of Art, New York. Robert Lehman Collection, 1975.1.31

19 Hans Baldung Grien (German, 1484/85–1545). *The Bewitched Groom*, c. 1544. The Metropolitan Museum of Art, New York. Rogers Fund, 1917

20 Detail of a page from a Psalter, Use of Sarum (The Rutland Psalter; England), c. 1260. The British Library, London, MS 62925, fol. 73r

21 Illustration from W. E. Tate, *The English Village Community and the Enclosure Movements* (London: Victor Gollancz, 1967), p. 89

22 Illustration from W. E. Tate, *The English Village Community and the Enclosure Movements* (London: Victor Gollancz, 1967), p. 129, pl. 9

23 Detail of the city of Coventry from the Sheldon Tapestry Map of Warwickshire, c. 1588–90. Warwickshire Museum Service (on display at the Market Hall Museum, Warwick)

24 The Limbourg brothers (Dutch, act. 1385–1416). *Très Riches Heures du Duc de Berry: Juin (June)*, c. 1412–16. Musée Condé, Chantilly, France, fol. 6

25 Hydrus; detail from a Gothic Bestiary (North or Central England), 1200–1210. The British Library, London, Royal MS 12 C. xix, fol. 12v

26 A black sun (*sol niger*); miniature from the alchemical treatise *Splendor Solis* (Germany), 1582. The British Library, London, Harley 3469, fol. 30v

27 Illustration from W. E. Tate, *The English Village Community and the Enclosure Movements* (London: Victor Gollancz, 1967), p. 2, pl. 1

28 Master of the Osservanza (Italian, act. c. 1430–50). *The Temptation of Saint Anthony Abbot*, c. 1435–40. Yale University Art Gallery, New Haven. University Purchase from James Jackson Jarves, 1871.57

29 Diagram of the stage of the white elixir, a queen or *Rosa alba* (white rose); miniature from the alchemical treatise *Donum Dei* (Germany or Austria), 2nd half of the 15th century. The British Library, London, Sloane 2560, fol. 14

30 Hercules Segers (Dutch, c. 1590–c. 1638). *River Valley*, c. 1626–30. Rijksmuseum, Amsterdam, SK-A-3120

31 Hercules Segers (Dutch, c. 1590–c. 1638). *Rocky Landscape with a Man Walking to the Right, First Version*, c. 1615–30. Rijksmuseum, Amsterdam, RP-P-OB-824

32 The chemical union of the red king and the white queen; miniature from the alchemical treatise *Donum Dei* (Germany or Austria), 2nd half of the 15th century. The British Library, London, Sloane 2560, fol. 7

Erica Battle Rachel, your new work, *Wil-o-Wisp*, is the inaugural Future Fields Commission in Time-Based Media at the Philadelphia Museum of Art and the Fondazione Sandretto Re Rebaudengo in Turin. As we talk today, in advance of the work's unveiling in Philadelphia in May, *Wil-o-Wisp* is still very much in process. I recently looked through some of the documentation of our initial conversations, when we were talking through different possibilities for the commission, and I ran across our first draft proposal from August 2016.

Rachel Rose Wow.

EB You said something in it that still feels applicable. At that point we were talking about general ideas that could give shape to a particular subject, but the subject had not yet manifested. You wrote, "I've chosen to make this [work] through narrative, and not purely editing, to more fully link two

Following Foolish Fire:
Exploring New Narratives with Rachel Rose

Erica F. Battle
Rachel Rose Studio, New York
February 9, 2018

real-life events that share an underlying question: How does containment distort perception?" It was that question that gave us a framework to move forward. You had also commented in an early conversation that you liked "the quality of internal combustion and the idea that distortion is internal." I want to work through some of those early ideas with you and how, over the course of the last eighteen months of this project, you've explored and expanded them through the historical subject you ultimately landed on, which is rural England in the early 1600s. Can you talk about how you imagined containment, combustion, distortion, and perception might have operated in this specific chapter of European history?

RR One of the things that brought me to this time period, early seventeenth-century agrarian England, and to creating a fictional town—and specifically to developing a story of one fictional woman—is the continuum between landscape and the self that was central to the

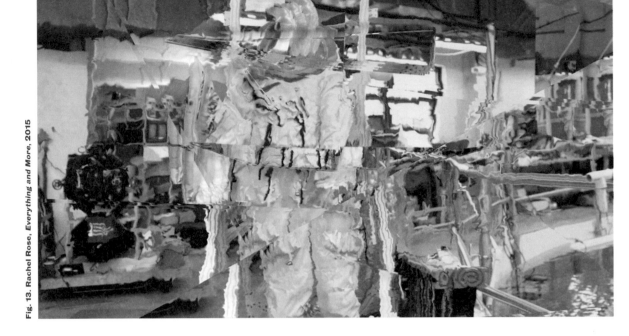

worldview then. The enclosure movement brought about privatization of what had been public or serf land used loosely for farming and for a whole host of other purposes within a community. And when that land was broken up and privatized [see pp. 27, 28], it created, on a mass scale, a refugee crisis, and on a more micro scale, a reshaping of the role of women within a community. This severing and breaking up of the landscape was also a severing of a specific understanding of cause and effect. Before, being isolated—without electricity, surrounded by death—a person's entire perspective was filtered through these social, physiological conditions. If a big hurricane blasted through a forest, toppling the trees, someone might reason that it was because "I was ill yesterday and had a violent cough, and this cough traveled through the air to cause that gust of wind to bring down those trees"—or something like that. It was a time of distortion of perception and perspective.

EB It seems you landed on the enclosure movement through your research-based practice because it encapsulated your larger ideas within a specific context. What you're pointing to comes through in the literature about the enclosure movement, which indicates that it was not just a matter of privatization or compartmentalization of physical space, but that the act of physical division had an effect on the body, as you were saying—that perception was distorted through the body. You're also talking about a kind of coincidence that was burdened with suspicion

and a new idea of causality, which comes through in the narrative you developed. I want to talk a little about coincidence and causality, because I think within the larger story you're telling in *Wil-o-Wisp* they manifest in very different ways than in your previous works.

RR Right.

EB Those ideas have been inherent to your work all along, from early works like *Sitting Feeding Sleeping* [2013] to *Everything and More* [2015] and *Lake Valley* [2016]. The perspective you explore in these works is circumscribed by ideas of inside and outside, containment, and perception—like the zoo in *Sitting Feeding Sleeping*, or the astronaut's story in *Everything and More*, in which he describes having an almost out-of-body experience in space that directly affects his reentry to life on earth, with its gravitational pull [fig. 13]. In *Lake Valley*, your most recent video, a hybrid animal seems to take viewers on a journey as it explores the inside and outside world. I find these ideas around defining the spaces of experience to be a through-line in the subjects you take on in your work. Can you talk about the bodily space, the psychological space, and the social space you're interested in exploring through your subjects?

RR While working on this project I was looking at more recent ideas of coincidence—Jung's idea of synchronicity in his book *Synchronicity* [*Synchronicity: An Acausal Connecting Principle*, 1960]—and thinking about how a current everyday experience might correlate to ancient

Fig. 14. Rachel Rose, *Sitting Feeding Sleeping*, 2013

symbolism. While I was reading Jung on synchronicity, I was also reading Arthur Lovejoy's text *The Great Chain of Being* [1936], which describes the worldview of seventeenth-century England as stratified, with each aspect of this stratified sphere, this "chain of being," connected. The chain of being linked life and the afterlife, the everyday and the surreal, dirt and an angel, a person and stone. In Jung's idea of synchronicity, what we experience on the surface of our everyday lives as coincidence feels that way because there are underlying structures beneath all that we know, to which everything is attuned or a part of, and this is not unlike the great chain of being.

EB Right.

RR From this perspective, when a coincidence happens it's not caused by a random set of forces; it occurs because these two things have cropped up from the same underlying source. In all my work, I'm trying to make connections between things that might seem distinct but that in fact share some underlying quality. This has often been a feeling, or a state of being. In *Sitting Feeding Sleeping*, the state of "deathfulness" links a cryogenic body and a zoo animal [fig. 14]. From this, going into the English landscape at the turn of the seventeenth century and a worldview that was so fully consumed with the idea of structures that connect was a way to access what I'm essentially concerned with.

EB Agrarian sixteenth- and seventeenth-century England and the enclosure movement gives you a setting, but can you talk about how you developed a set of characters and refined your focus to both reflect on coincidence and also give some shape and specificity to your ideas of storytelling and narrative?

RR One of the things about coincidence is that so much of storytelling hinges on it. Like the story that a couple randomly meets on a street because the guy walked by and the girl dropped her bag, and he picked it up, and then they fell in love—or something like this. This is the bread and butter of how stories are usually constructed. Writing a story with the idea of coincidence in mind was, oddly, just like writing any other story. Simultaneously, I was thinking about the animist worldview of the time, and how people saw magic as real and as transformational: a person could turn from human into something else, or could transfer sickness from a body into an animal and back into a person. This kind of alchemical idea of existence was fundamental to how people thought at that time. I tried to understand the different, practical ways people used magic in these agrarian communities, and I used that perspective as a

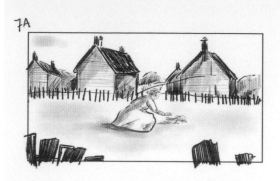

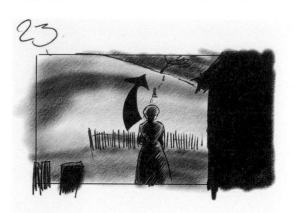

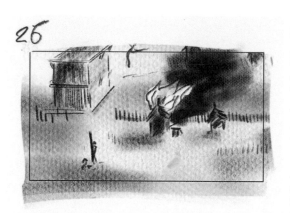

Fig. 15: Early concept storyboards for *Wil-o-Wisp*, created by Thomas Slattery

major plot point in the story. I looked at the figures who were actually conducting magic, and it was often women—precursors to the magician, or the wizard. These women weren't witches but healers, and also the backbone of their communities, since sickness and death were constant. I studied different examples and wrote a character who practices magic, and who is situated in one of these communities, to get a sense of how the privatization of land changed community roles and, as part of this, changed ideas of magic, transference, and animism.

EB There were different types of people practicing different types of healing magic. It was often women who were widowed or poor who ended up being persecuted more than others engaged in benign healing practices.

RR Right.

EB *Wil-o-Wisp* in a way hinges on this striking contrast between a history that is sometimes romanticized—courtly Renaissance England—and

its crueler reality. It also hinges on the complexity of characters and the wider symbolism they carry. There is this moment when the main character, Elspeth, is taken from her home, and it's implied that she is eventually executed offscreen, which allows her specific story to be told while she stands in for the universality of the fate experienced by women like her. It seems from historical accounts of rural life in those days that women in various circumstances shared similar fatalistic outcomes. You see this, too, in the storytelling of the time.

RR Yeah.

EB I want to talk a little about story construction and how—thinking about coincidence, distortion, and perception as through-lines in some of your other works—you landed on developing your ideas into narrative form [fig. 15]. I was wondering how you thought about narrative time in relation to historical time in creating this new work, in contrast to some of your previous works, in which you were dealing with distinct elements and bringing them together. In *A Minute Ago* [2014], for example, you bring together found footage of a hailstorm on a beach in Siberia [fig. 16] and footage that you shot of Philip Johnson's Glass House, over which you rotoscoped an image of Johnson giving a tour [fig. 17]. There's also a painting . . .

RR Poussin's *The Burial of Phocion* [c. 1648–49; fig. 18].

EB So you weave these different elements together. In both that work and others you tend to tackle what seem at first glance to be very disparate subjects, and you recombine them in the digital edit; you construct a visual correspondence that creates a larger meaning. But in *Wil-o-Wisp*, from the very beginning, you were interested in trying to approach the process from an entirely different angle, which is to develop a storyline and to find within it different juxtapositions, coincidences, and textures, rather than starting with those elements and weaving fragments together to

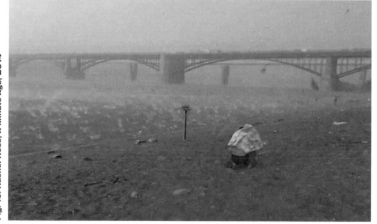

Fig. 16. Rachel Rose, *A Minute Ago*, 2014

37

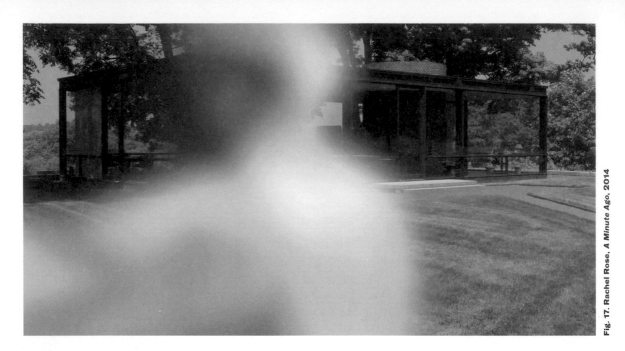

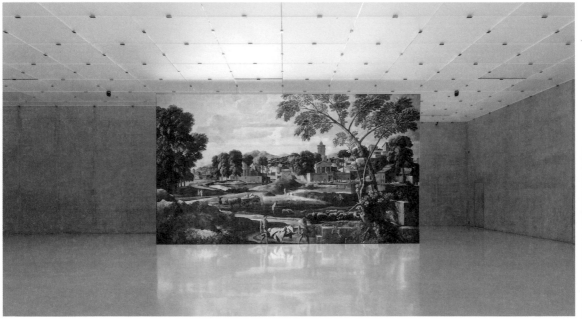

arrive at a whole. Why try this particular approach in the context of this commission? And what did you learn from the process?

RR With each of my works, I've been developing a protagonist. So maybe in *Sitting Feeding Sleeping* that character was me; you hear my voice and what I was thinking. In *Palisades in Palisades* [2014] that figure was, abstractly, the person in the park [fig. 19]. In *A Minute Ago* that figure was Philip Johnson, or the idea of his house, or something, over time. In *Everything and More* it was David Wolf, the astronaut. In *Lake Valley* it was a chimeric animal [fig. 20]. So the idea to write a story with a central character is something I've been inching toward. It's something I've been curious to learn more and more about. And I really felt a limitation, in a sense, in the somewhat documentary approach I've taken in previous works—going to a site, exploring it, recording it. On the one hand, it's given me a rich, specific site to work within to discover why I'm there. But on the other hand, I'm there only briefly and within limits, or I can interview a subject for an hour. I can't fall into the depths of the place I'm recording, because it's just not feasible in how my works have been structured. So I wanted to figure out a way that I could fall into a place and live there more fully, with more breathing room. One of the two ways to do that is to write a story that I can be in, and the other is to set the story in a place that allows me to fall into it— visually but also historically. Writing a story and choosing this time is like creating a fuller container.

EB Depth is something we've talked about a lot in the context of this work. Not only because it takes on a single subject in depth, but also in relation to the visual quality of what you're producing, which derives from live action, blocking actors, being on a physical set for a certain amount of time. There's a literal depth, which is that you're shooting in three dimensions, with full sets, interiors, and landscapes. And so, visually, you're not just collaging images together; you're creating a sense of place and a sense of time.

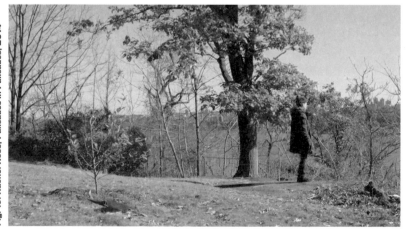

Fig. 19. Rachel Rose, *Palisades in Palisades*, 2014

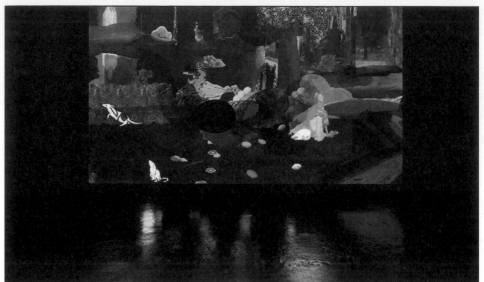

Fig. 20. Rachel Rose, *Lake Valley*, 2016. Installation at Gavin Brown's enterprise, New York, 2017

RR Yes.

EB Which is different, I would argue, from the approaches in some of your previous works. In this project you're investigating even more fully ideas of tableau, of scene-setting, of forming and framing images in a way that's very particular to a certain type of filmic process. Something we also talked about early on was the idea of "upholstering" history— that instead of using a historical framework for a narrative that has contemporary resonance, the historical framework itself was something that you wanted to layer onto, manipulate, and rearrange. I feel this when I watch the work, even though it's still in progress—this idea that the story doesn't disappear into the setting of Plimoth Plantation [fig. 21], but that this place gives space for something else to happen. I think that's a really magical aspect of this work, if I can use that word [*laughter*], because through its making you're achieving a completely different representation of your ideas.

RR Right.

EB To me, this has to do with your progressive relationship to landscape. It's been noted in many previous texts about your work and in interviews with you that you use landscape as a reference, or a referent. I was wondering if you could talk more about landscape in a structural way, because that's how I see you using it in *Wil-o-Wisp*. It's not so much that the painted landscape is a surface you're responding to aesthetically, but in fact you're moving deeper into figuring out how to use it, as you

40

were saying, to achieve a certain type of structural depth that creates a framework for the larger project.

RR There are three different ways I was thinking about landscape in this project. The first way was wanting to get inside an animated perspective on the landscape that was true to the time. In trying to come up with images for the way I ended up shooting this, one of the things I learned was that there weren't very many images of the landscape produced in the early 1600s. It was represented symbolically. Queen Elizabeth might be portrayed with ornamental flowers and eyeballs on her dress to show that she could "see all her land domain" [see p. 21], but the landscape wasn't represented as we see it later, in the eighteenth century, as something detailed and picturesque to behold.

EB Right.

RR And so I came to understand that the landscape was an inextricable part of how people saw themselves. It wasn't an "other." And that

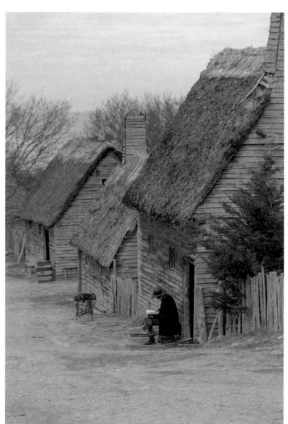

Fig. 21. Plimoth Plantation, Plymouth, Massachusetts

brought me to film scores from the 1950s and 1960s, when you see these spectacular landscapes presented sensorially—for example, in *Spartacus* [1960], which has a film score that romanticizes the landscape as though it's a person. So I ended up working with a piece of music that was written for *Spartacus*, called "Blue Shadows and Purple Hills." It's a highly emotional, orchestral score for the landscape. It felt so in line with this 1600s animist perspective on the landscape. Essentially I recognized that if I was going to produce an emotional dynamic with the landscape it wouldn't come through an image— that it would need to come through sound. So that's one way. The second way, working again in sound, was studying agrarian chants from the time—what people were singing when they worked, in their homes, and how they were transmitting stories through song across the

landscape. The poet Josh Stanley took the story and wrote a narrative poem in iambic pentameter. And then, working with the composer Isaac Jones, using music originally written for the flute, we transposed this poem into a melody, which is then sung. In this way the story is told with some similarity to how stories were told in that era. And the third way I thought about the landscape was visually, as an animating principle in itself—the land as not separate and still. I wanted to capture this perspective. How could the landscape of *Wil-o-Wisp* transform itself as the story transformed? As the story progresses, and loops back in time, the visuals become increasingly saturated with the pigments that were used in illuminated manuscripts. The symbolic blues and greens for sky and grass, and gold for light [see p. 28], grow and bleed into the gray landscape in the footage of the real Plimoth Plantation.

EB The use of "Blue Shadows and Purple Hills" struck me when I heard it in an early edit of the work. I didn't know the origin of the score then, but my immediate thought was of movies of the 1950s and 1960s. Yet its use isn't about ideas of fidelity or authenticity to historical time; you're creating your own narrative time. That's what I was trying to get at before: it's not just the re-creation of a realistic moment, but the creation of a feeling that we get of that moment from the images, the score, and the crafting of the video itself.

RR Right.

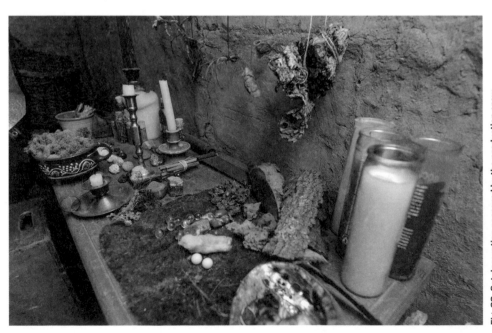

Fig. 22. Set decoration prepared by the production crew

EB This isn't an attempt to re-enact or to create something that's historically or art-historically linear. You're creating a meaning that comes from a synthesis of visual and aural references that contribute to our understanding of that time and that amplify an emotional connection. You've also built in "tells" or "reveals" that make it clear that this is not a period piece [fig. 22]. The synthetic creation ends up somehow feeling more authentic to our contemporary bodies, because we're the sum of our memories.

RR Yes.

EB What about the choice of shooting at Plimoth Plantation? What was it about that site that spoke to you?

RR When you're there you can feel how vulnerable and permeable the living conditions were in these agrarian communities. The wooden houses could burn down at any second. They were single-room homes for a family [fig. 23]. Plimoth Plantation allowed us to see how living really was then. And the specific, transportive feeling of Plimoth as a site significantly affected the development of ideas in *Wil-o-Wisp*. Being there synthesized a feeling of the time.

EB Were there other decisions related to time or this synthesized feeling?

RR I don't know if this has to do with time so much, but one choice that would not be visible in the work is that, in the casting process, professional theater actors were chosen for all the women's roles, and all the men are either improv actors or were street cast. This was a formal decision, not a political one; it was about trying to set in place this feeling of the power that some of these figures had at the time, and trying to let that infiltrate the way the piece was made.

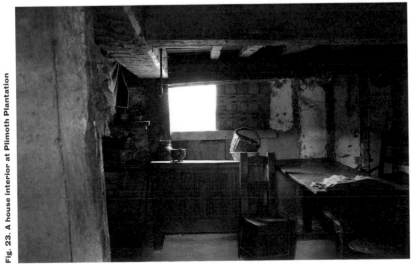

Fig. 23. A house interior at Plimoth Plantation

43

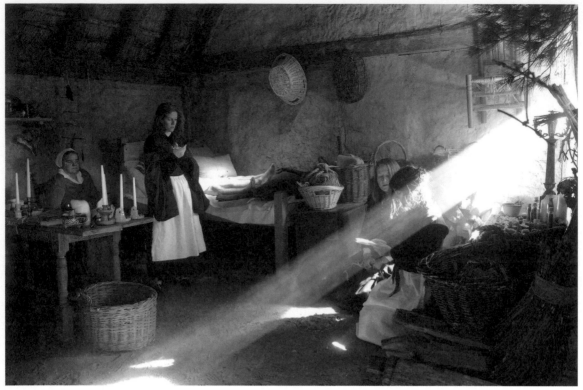

Fig. 24. Elspeth with extras on set

EB Ironically, the power dynamic within the story plays out in completely
the opposite way: the men have the power and control to threaten
and persecute the women. But that's putting it rather simply. Your
characters are strong women, especially Elspeth. The woman who
plays Elspeth is incredibly talented and professional [fig. 24], and
the fact that the man spying on her, the man who plays the prefect,
is walking onto the set with an improvisational acting background—
it flips the script in a really interesting way, even if the differences
register subconsciously, or at all. You worked with some other profes-
sionals or specialists during this process as well. Can you speak a bit
about that?

RR The healing sequence was written and scripted around the ritual of
transference between beings, so in the scene there's a dove and a
butterfly, the healer and someone who's dead who she brings back
to life. We worked with the healer and art historian Diana Mellon, who
walked the actor and me through the healing practices of the time and
how transference might have been practiced then [fig. 25]. For the
costumes, we worked with a designer whose work is heavily influenced
by seventeenth-century agrarian design.

EB What about the writing process? Where did you start?

RR Part of it was based on a real-life tragic event I read about a few years ago, which I had pursued and researched but was unsure how to approach. This was a story I read in a local newspaper about a fire that was started by a son when he came home from college: he was smoking a cigarette, and the cigarette fell in the bushes near his house, burning the whole house down and killing his entire family with the exception of him. It was tragic and horrific that such a small gesture would cause such pain. I was struck reading this in the paper; it felt like a scripted tragedy. And this led me to be interested thematically in tragedy in stories. I started re-reading some of Shakespeare's tragedies and then reading biographies on Shakespeare, which led me into his surrounding world, because his works are inextricable from his context. Once there, I got into the enclosure movement. I studied individual stories and pieced them together with actual events and exchanges that were on record to create a fiction.

EB I remember talking about this idea of the fire early on, and you not wanting to transcribe that event directly into the subject of a work, but

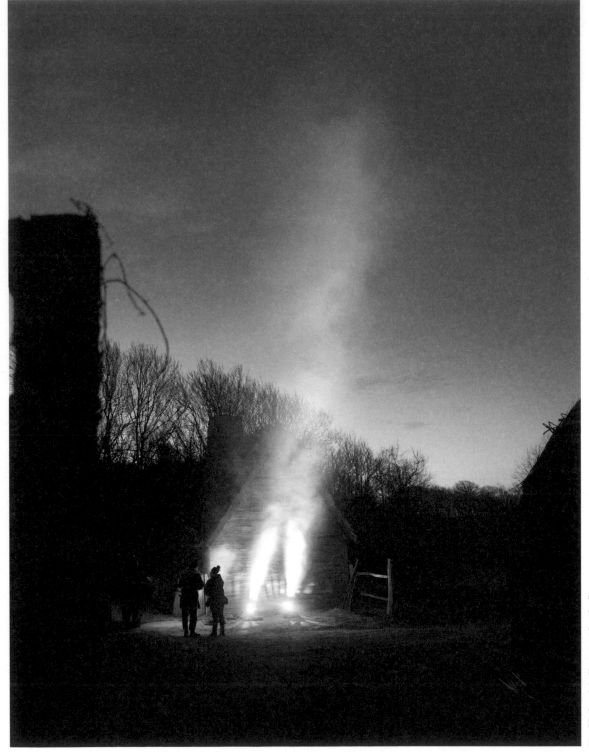

Fig. 26. Special effects test for the fire scene

somehow to build on that horrible coincidence and the tragic fate of this individual.

RR What did these things mean? And where does it situate us, when something like that can happen?

EB In the work as it stands, there's a moment that speaks directly to this early kernel of an idea, which is when Celestina, Elspeth's daughter, gets up in the middle of the night to meet her lover [fig. 28], and she drops her bonnet too close to the fire, which results in the house burning down [fig. 26]. What I appreciate about the way you've inserted that initial idea into the narrative is that, instead of it being the dénouement, it's the coincidence that sparks the rest of Elspeth's fate. So you've found a way to fit this idea within a larger concern.

RR Yes.

EB In working with you on *Wil-o-Wisp*, I became much more aware that you're not just concerned with visual art but with broader visual culture—for example, you know so much about the history of cinema. Your work expresses a concern with how we visualize the world and how we experience it through that visualization. What I was struck by most was how this process of directing a film came very naturally to you, as did working on set with a cast and crew of about thirty people [figs. 27, 29].

RR Right.

EB But more than that, you were able to figure out the technical reality of your idea—to think through the visualization and the realization of an idea simultaneously. How did you think about the mechanics of cinematography in the process of making this work?

RR I wanted there to be almost no movement of the camera. There are a few dolly shots, but for the most part the camera is still, not drawing much attention to itself.

EB This is different from so much of current cinema, where the cuts are really quick.

RR Exactly. In order to create space for the sound, the visual effects, the change in color saturation, and the quick succession of events over such a wide time span in the story, the stillness of the camera was essential. Its steadiness allowed room for all this.

EB You also frame scenes in a very particular way and use the contrast between the warmth of interiors and the austerity of the landscape almost as opposing emotional states. The inside-outside structural framework of *Wil-o-Wisp* is something you've worked with before. It happens in *A Minute Ago*, for example, with the glass panes of the Philip Johnson Glass House acting as a membrane between the natural world and an artificial, architectural world [fig. 30].

RR Right.

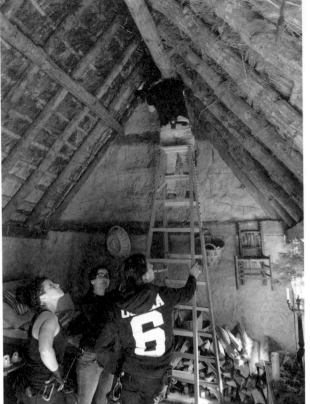

Fig. 27. Production crew preparing a house interior

EB In *Palisades in Palisades*, the palisade itself is an obstruction—the physical phenomenon of a large cliff demarcating the Hudson River from a park designed by Frederick Law Olmsted. What I think is interesting about the way *Wil-o-Wisp* uses interior and exterior is that physical and real boundaries stand in for different types of lived experiences in terms of how we navigate our bodies. Sometimes these boundaries are more psychological. Why are boundaries so important to you, and how do they help you think through your subjects?

RR I guess I'm always asking myself what counts as inside of me and what counts as outside of me. What counts as an edge? If everything is permeable to everything else, what does edge mean? It's definitely why I make art—to think about this.

EB So for you as an artist, this navigation of edges and boundaries, between the real and the imagined, the physical and the psychological, seems to be essential. What is it about this idea that is so fundamental?

RR I'm not sure. I'm endlessly working on it—to try to lock it into something that unfolds that for me. I feel that my job when I'm editing is figuring out what you're asking. So I don't have a good answer for that yet.

EB What about the commissioning process? How has this been similar to or different from how you've produced work in the past?

RR It's completely different! [*laughs*] I never could have accomplished this shoot without it, and I never would have gone into a site and a time period so fully. The depth of engagement with the site and with this history is completely a result of this commission.

EB Can you talk about the title? Why *Wil-o-Wisp*? Is the meaning of a will-o'-the-wisp folkloric, historical, or symbolic to you? Because there is no actual will-o'-the-wisp seen in the work, or maybe just for a minute . . .

RR We cut the will-o'-the-wisp.

EB Right.

RR Will-o'-the-wisps are said to be flickers of light caused by swamp gas. They were interpreted as an omen, like the way we think of a shooting

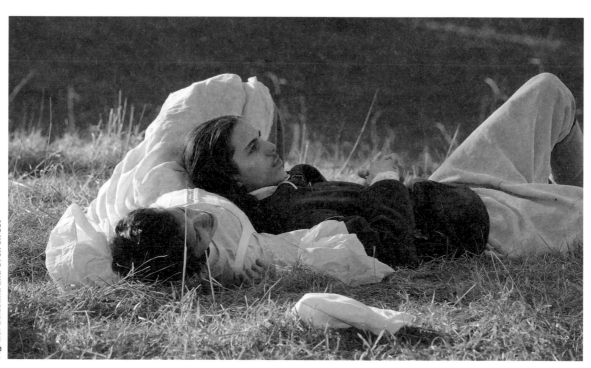

Fig. 28. Celestina and Oren on set

star, but in the landscape rather than the sky. They were of the magical realm. In my original script it had a much more central role, so *Wil-o-Wisp* is a relic. I like the sound of it, too. It sounds melodic and connected to the sung tale in the voiceover.

EB I don't think the will-o'-the-wisp has to literally be seen in the work, because it's its own imaginary idea. The Latin name for it is *ignis fatuus*, which translates as "foolish fire." It's a signal of some kind, a manifestation within nature that leads people astray. This is the English folkloric take on it, but the idea exists in multiple cultures. There are very similar phenomena throughout the world. There's an area in Massachusetts near Plymouth where they have reportedly been seen.

RR Oh!

EB This idea of the natural phenomenon of the will-o'-the-wisp plays into a nonliteral reading of the scope of the narrative and is a beautiful way to think about it. Essentially the characters Elspeth and Celestina have their lives pulled apart; they are led astray. There is something cyclical in the work, and something cyclical about the belief systems it explores as well. The moment after the fire when the cow appears, and is taken for Elspeth, has a ripple effect in her future. This idea of mistaking one thing

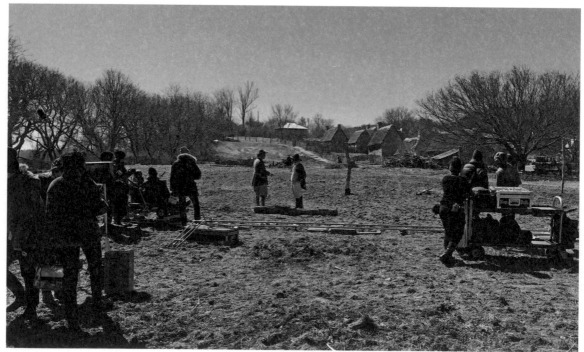

Fig. 29. Production crew filming a scene

Fig. 30. Rachel Rose, *A Minute Ago*, 2014

Get a cover!

for another is very much there. The idea of mistakes being made, of being led astray and the harm that results—all that is there as well. And there's the more contemporary usage of *will-o'-the-wisp*, as something that's hard to pin down or articulate—the elusive quality of the will-o'-the-wisp. It's powerful to think that the decisions characters make, the coincidence that propels the plot, and the vulnerability of the townspeople to the external circumstances of the enclosure movement all converge to determine their fates. You're combining the history of the time, the reality of the time, and the feeling of the time to create a new narrative time, without relying heavily on folkloric storytelling.

RR Right.

EB That was really long! [*laughs*]

RR Yeah. I think that's a good way to end it.

Wil-o-Wisp Installation and Stills

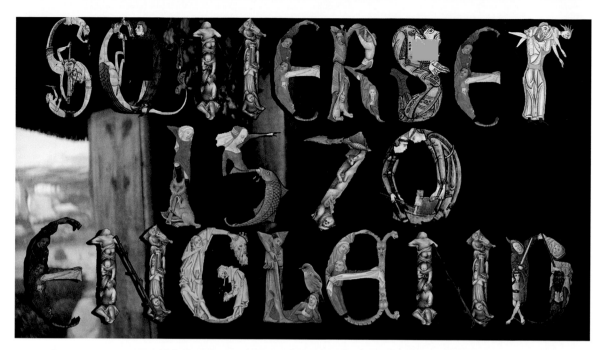

SOMERSET 1570 ENGLAND

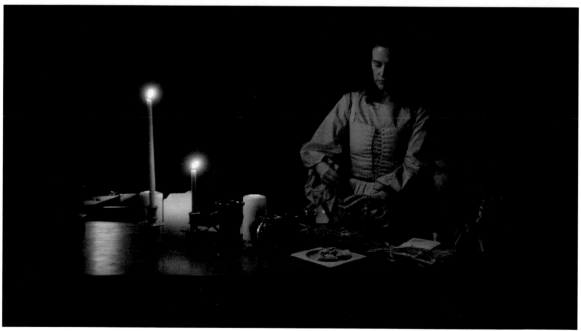

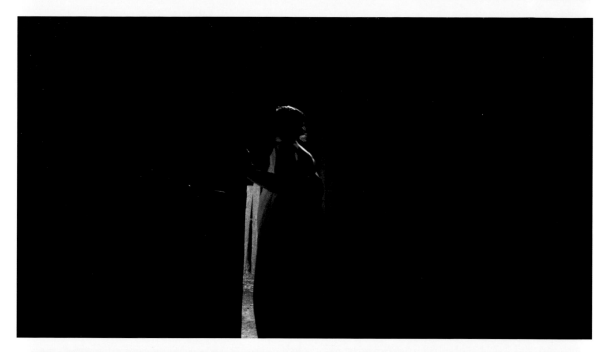

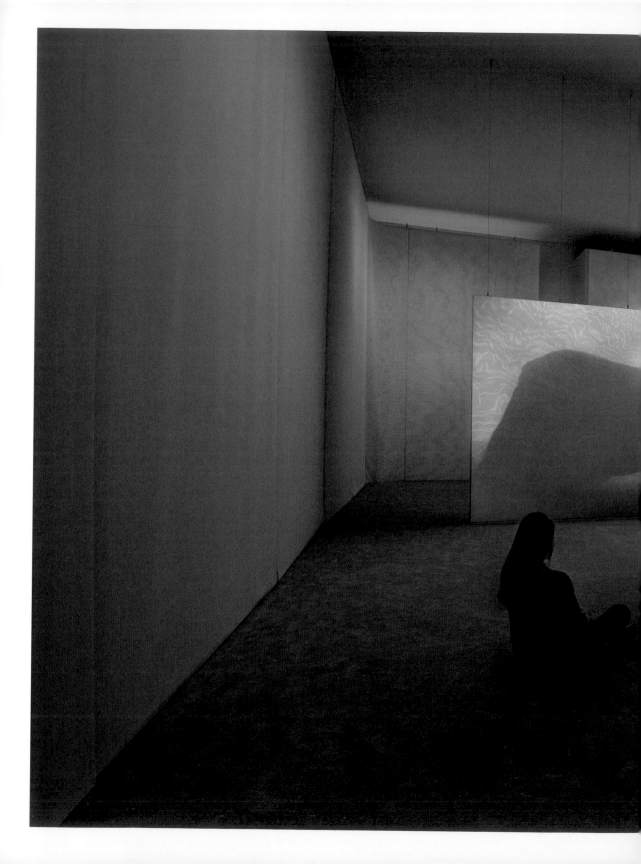

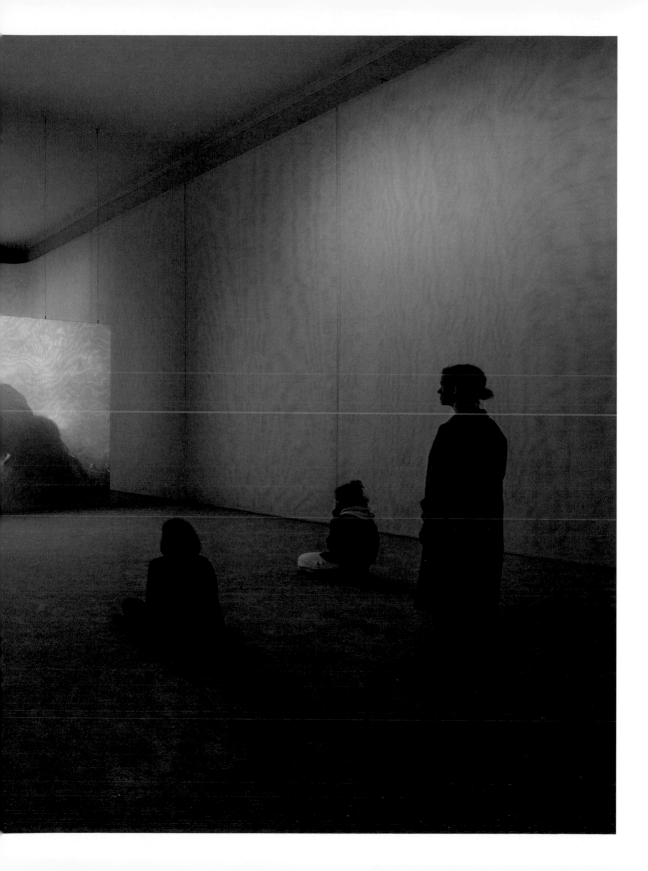

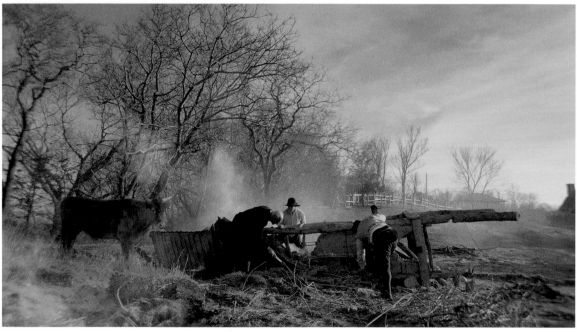

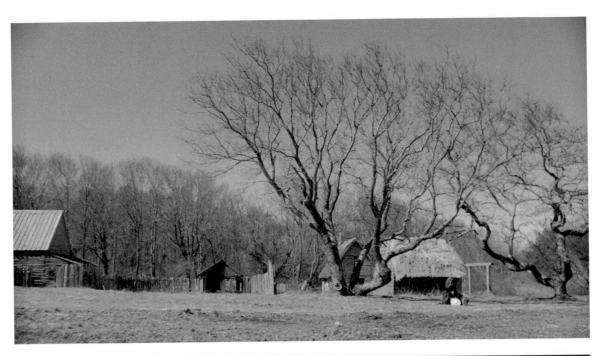

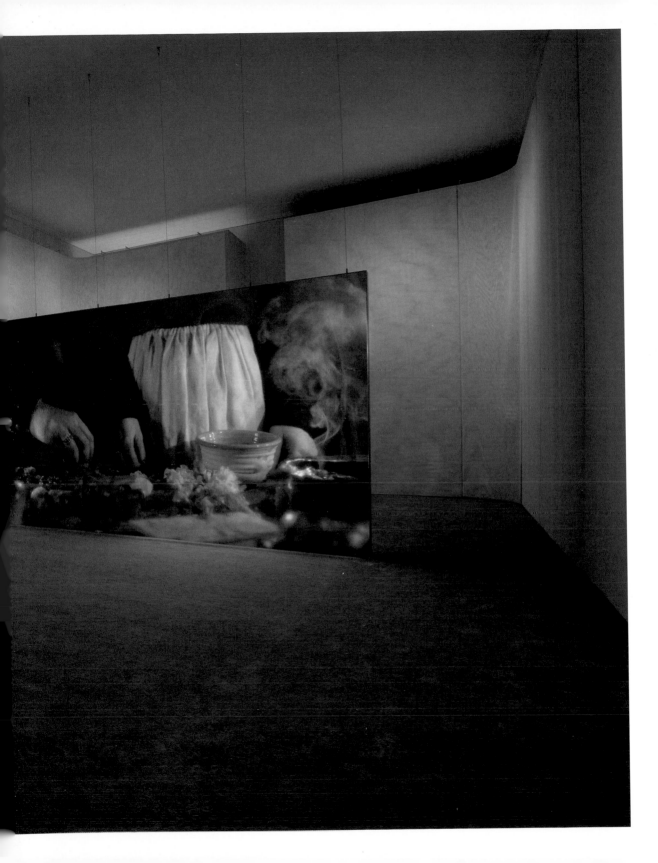

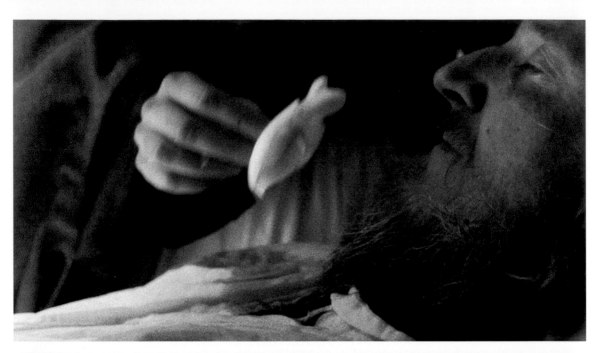

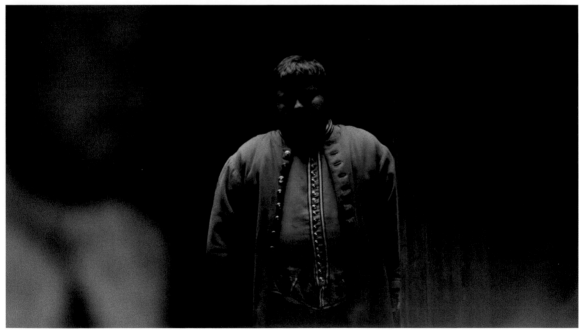

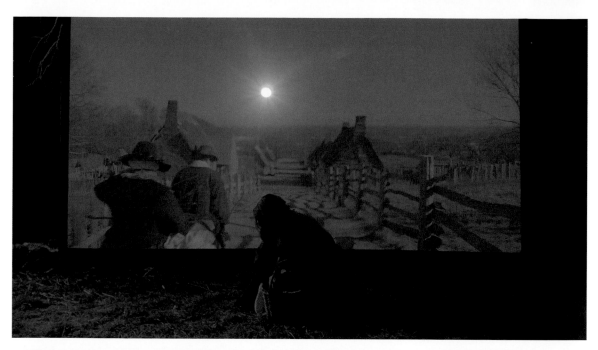

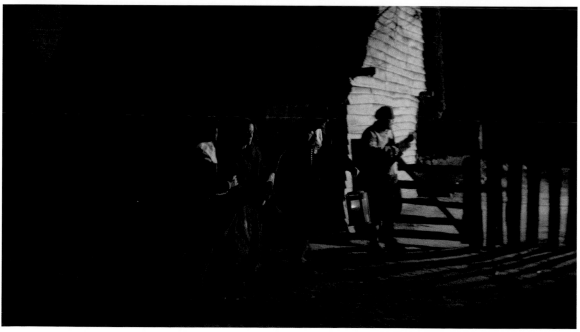

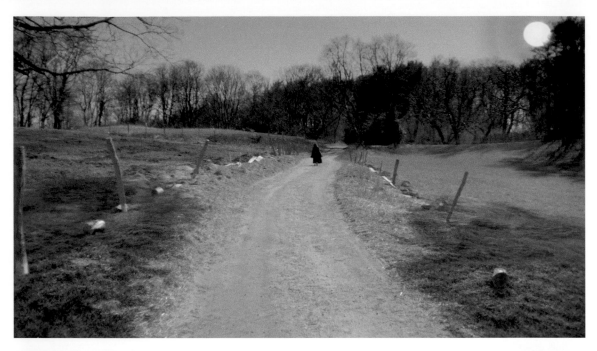

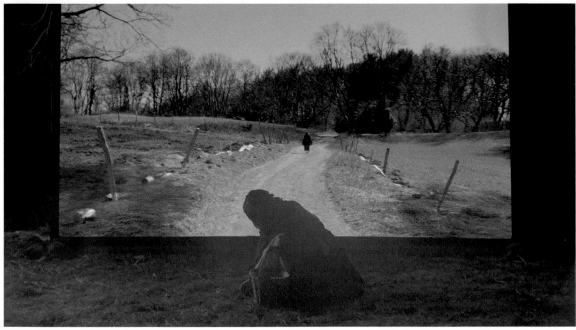

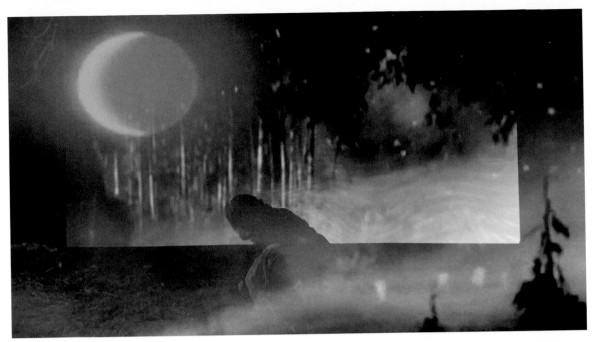

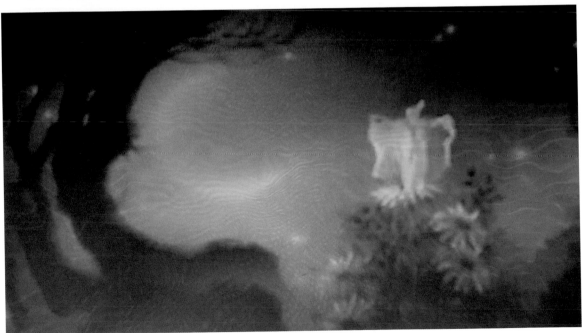

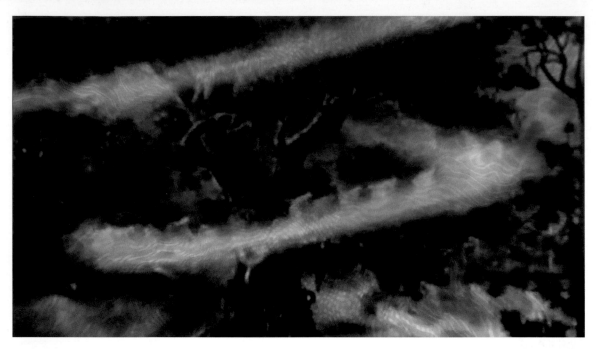

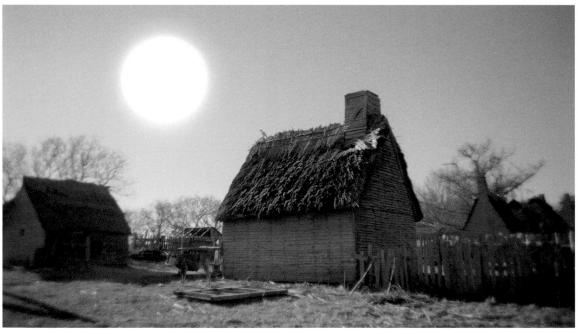

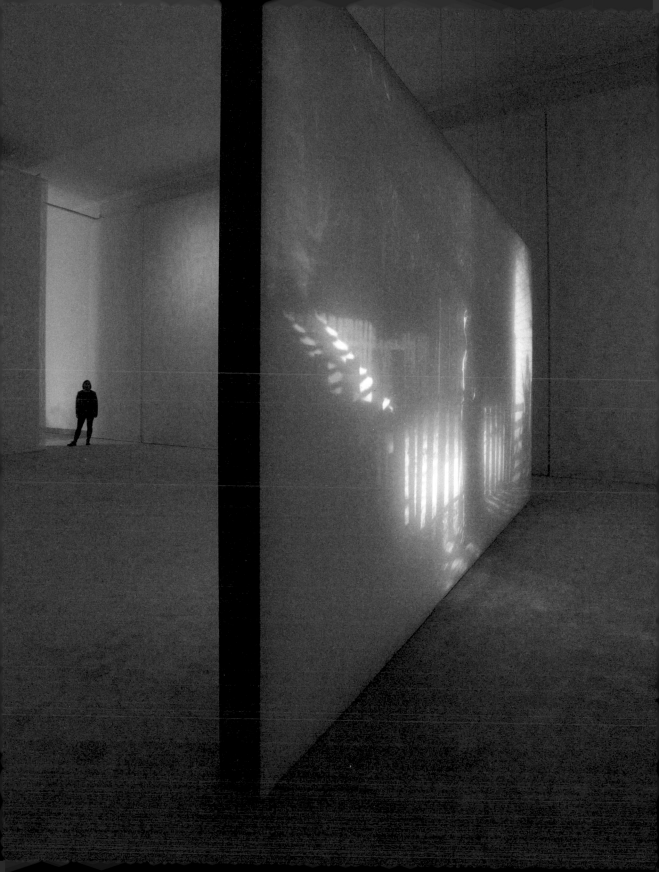

> The map had been the first form of misdirection, for what is a map but a way of emphasizing some things and making other things invisible?
> — Jeff VanderMeer, *Annihilation* (2014)

Epilogue and Acknowledgments

Erica F. Battle

As Rachel Rose endeavored to find a subject for a new work as the first recipient of the Future Fields Commission in Time-Based Media, she contemplated an essential question: How does containment distort perception? Landing on the enclosure movement in England, she located a time, a place, and a worldview that were shifting radically, and sometimes violently, from notions of common land and community to the proprietary interests of individual ownership. Enclosure redrew England—as the maps produced during those centuries attest—and reshaped its social and political fabric, as Rose explores in her new work, *Wil-o-Wisp*.

Pervasive in Rose's work is the idea of the edge—edges that, when so forcibly articulated in historical examples such as enclosure, inevitably exclude as well as include, and forsake as much as they protect. Rose pursues an effective analogical thread, coupling her history-driven narrative with an exploration of the phenomenological threshold between the experienced and the imagined. Layering onto her live-action footage a myriad of effects—swirling moiré, churning smoke, images superimposed on screens—she suggests that the act of perceiving can redraw reality and turns viewers of the work into witnesses to historical exclusion, and to the tension between visibility and obfuscation.

In the final form of the installation, which was just beginning to take shape at the time of the interview included in this book, these relationships are also present in the material

spillage that occurs between the screen and the surrounding space. Utilizing moiré both as a digital filter over images projected on the screen and as a physical phenomenon on the walls of the gallery, double-lined with white mesh, Rose creates a coalescence between the historical time of her subject and the contemporary lens through which we comprehend the past. The screen itself is formed of two sides of semitransparent material, furthering the refraction between image and light to create, on the back, a doubling of images, which seem to shift like a moving lenticular picture.

That a contemporary artist would dive so deeply into the past is at once revelatory and reassuring: we can learn from our histories if we can comprehend and acknowledge that they are cyclical. Artists like Rose remind us that looking back can inform how we forge ahead. This is, at its heart, what the Future Fields Commission seeks to do: become a platform for the creation of new work that can inform us about our cumulative present and, by creating opportunities and taking risks, fashion future paths for durational media.

In so many ways, Rose's *Wil-o-Wisp* speaks to the fragility inherent to our navigation of the world. I am fortunate to have worked alongside so many people whose inspirational roles, remarkable efforts, and collaborative spirit helped me navigate the multifarious project of commissioning, presenting, and publishing a new work. Without the steadfast leadership of Timothy Rub, the infectious enthusiasm of Patrizia Sandretto Re Rebaudengo, and the expert guidance of Carlos Basualdo, the Future Fields Commission in Time-Based Media would not have gotten off the ground. It was their initial conversations, which soon came to include me as well as Amanda Sroka, our spirited

assistant curator of Contemporary Art, and Irene Calderoni, the indispensable curator at the Fondazione, that laid the groundwork for our institutional collaboration.

At the Museum, the members of our Contemporary Art Committee (named on p. 74) embraced Rachel Rose's project proposal. I thank them for their support and enthusiasm in exploring a new process for producing a work, which we would not only commit to showing in both Philadelphia and Turin, but also bring into our collection as a co-acquisition with the Fondazione.

The exhibition of *Wil-o-Wisp* in Philadelphia was generously supported by The Pew Charitable Trusts, The Daniel W. Dietrich II Fund for Contemporary Art, Lyn M. Ross, Emily and Mike Cavanagh, Susan and James Meyer, and Mitchell L. and Hilarie L. Morgan. Pilar Corrias and Gavin Brown's enterprise, Rose's galleries, were instrumental in the realization of this publication through their generosity, and I extend special appreciation to Pilar Corrias and Lara Asole, and to Gavin Brown, Elizabeth Koen, and Kyla McMillan.

There is no doubt that each project undertaken at the Museum is achieved through a singularly collaborative and collegial process in which artistic and curatorial ideas are supported by the depth of expertise of our staff. While many of these individuals are named below (see p. 74), I would like to single out those whose insights significantly underpinned the commission and the exhibition, which at times were quite intertwined: Allison McLaughlin, collections assistant in the department of Contemporary Art; Helen Cahng, exhibition designer; Stephen A. Keever, audiovisual services manager, Aaron Billheimer, our former audiovisual systems specialist, and Brandon Straus, audiovisual technician. Each brought his or her particular skills as well as patience,

humor, and diligence to this project, and together they formed a collective and good-spirited body that moved with remarkable and much-appreciated agility to achieve an elegant and compelling installation.

This book gives us further opportunity to reflect on the cumulative experience of bringing a new work into the world. I am most thankful to its editor, Kathleen Krattenmaker, whose meticulous and incisive attention ably ensured its quality and impact. I thank Erika Balsom for her astute and lyrical text, which weaves Rose's new work into a wider narrative of the history of moving images. In the department of Publishing, it was a pleasure working with Katie Reilly, the William T. Ranney Director of Publishing, and Richard Bonk, production manager, to usher this volume from concept to cover stock to finished book. I also thank Luiza França, curatorial intern, who dove into the essential work of amassing images and took on the unquantifiable role of cheerfully handling an array of miscellany throughout the project. Finally, I am grateful to Ken Meier and Yoonjai Choi of Common Name, whose design carries us through the journey of *Wil-o-Wisp* with their characteristic contemporary elegance.

Rose is fortunate to have at her side a number of key collaborators and invaluable assistants, and to have worked with a talented cast and crew for this project; I join my thanks to hers for their crucial participation. In our work together, I have especially appreciated the whip-smart insights of Jessica Wilson, her studio manager, and the dedication and diligence of Claire Sammut, her studio assistant. Andrew Chan Gladstone, the producer of *Wil-o-Wisp*, was instrumental in realizing the work within the limits of our resources and time. At Plimoth Plantation, we could not have achieved the film shoot without the enthusiasm of Kate Sheehan, manager of media relations and promotion, and Rob Kluin, director of marketing and communications, and the support—as well as on-screen participation—of Kate LaPrad, executive director.

Finally, I express my infinite thanks to Rachel Rose, whose visionary and visually compelling work possesses a mesmerizing magnetism rivaled only by that of the artist herself. Rigorous in research and process, Rose is equally open to the influences of the world and guided by her fascination with the iterative nature of history and images. I am truly thankful for her openness in developing such a close artistic and curatorial collaboration, which propelled the possibilities of this project and compelled a striking new trajectory in her evolving work.

Mapping out new worlds of meaning through her digital, and now narrative, storytelling, Rose invites us to rethink the edges of our own reality. While the world is inevitably exposed to evolving external forces that redraw and reshape it, *Wil-o-Wisp* will live on in our collections, continuing to recount its story of enclosure, perception, and magic to audiences in Philadelphia and Turin for generations to come.

The artist would like to extend special thanks to the following people who participated in the making of *Wil-o-Wisp*:

Jessica Wilson, studio director and producer; Andrew Chan Gladstone, producer; Nikkia Moulterie, line producer; Emily Lesser, production manager; Christopher Zou, assistant director; Alana Bonilla, second assistant director; Elizabeth Stern, script supervisor; Danica Pantic, production designer; Amanda Carzoli, prop master; Angel Bellaran, set decorator; Lauren Crawford, set dresser; Claire Sammut, vocals and studio assistant; Diana Mellon, consultant; David Raboy, director of photography; Ashley Thomas, hair and makeup artist; Savannah Wyatt, costume designer; Akua Murray Adobe, hair and makeup/costume assistant; Yessica Curiel Montoya, gaffer; Marcia Garcia, key grip; Kayla Grossman, manager, Historical Clothing and Textiles, Plimoth Plantation; Elizabeth Stern, script supervisor; Kate Sheehan, manager of media relations and promotion, and Robert Kluin, director of marketing and communications, Plimoth Plantation; Isaac Jones, libretto, original music and sound design, mixing and mastering; Kelly Jones, guitar; Nico Osborne, guitar; Josh Stanley, poetry; CF Goldman, clothing; and Pilar Corrias, Gavin Brown, Lara Asole, Thor Shannon, Lucy Chadwick, Kyla McMillan, Ian Cheng, and Veronica So.

She also thanks the cast:

Ann-Marie Lawless (Elspeth Blake); Yadira Guevara (Celestina Blake); Ade Richardson (Samson Blake); Emma Love (Grace Blake); Andrei Alupului (Prefect); Aaron Kheifets (Bailiff); Jeremiah Torres (Oren); Kate LaPrad (Girl on Post); Jeff Kucukistipanoglu (Townsman Abe); Paul Kandarian (Townsman #1); Kevin Groppe (Collapsing Man); Jesse Christensen (Townsman #2); Bill Rudder (Sick Man); and Daniel Connelly, Rachel Emmons, Emily Lesser, and Finlay Smith (Crowd).